LA PEDRERA

A work of "Total art"

JOSEP MARIA CARANDELL
Text

PERE VIVAS
Photography

TRIANGLE POSTALS

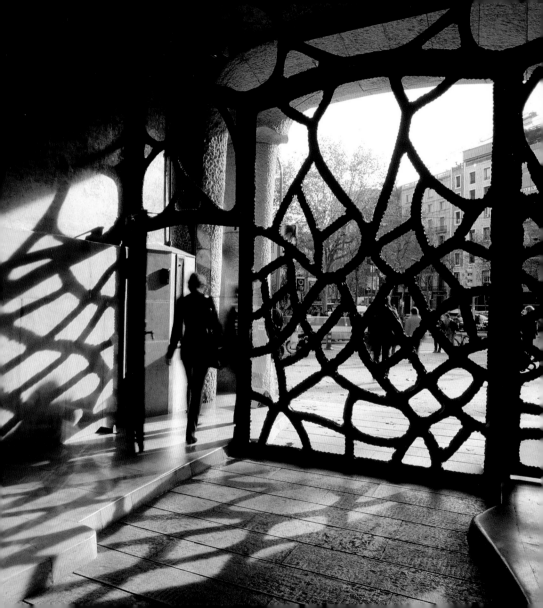

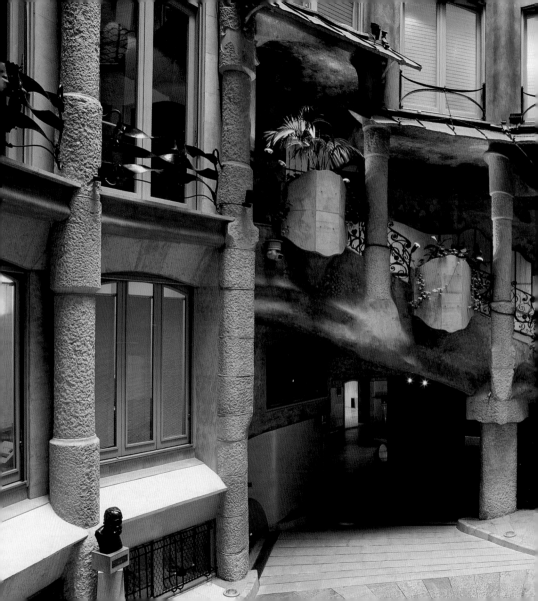

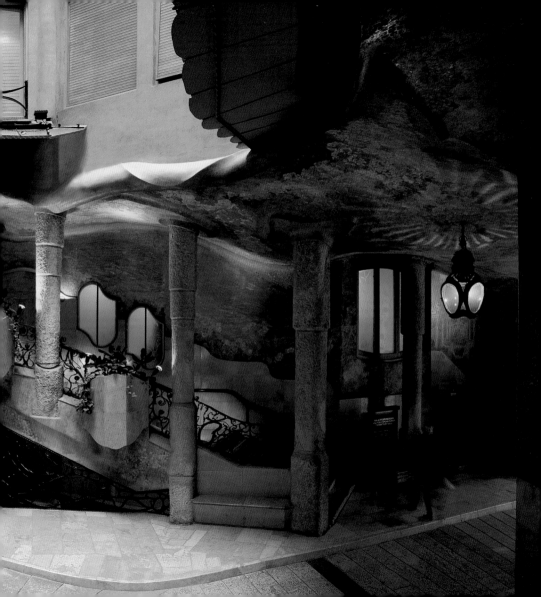

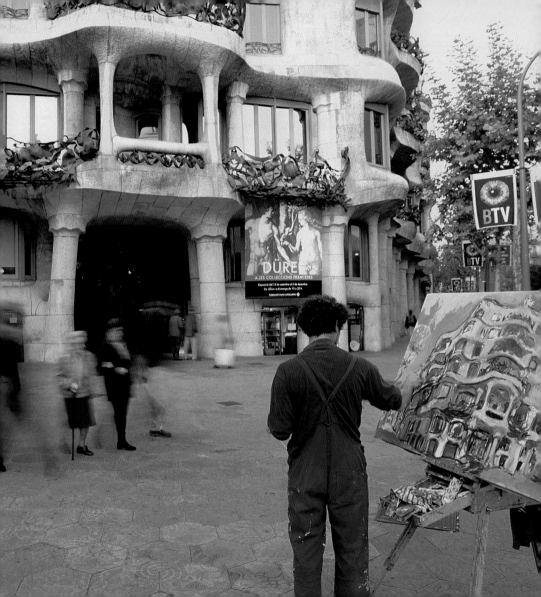

A house in Passeig de Gràcia

The Milà family, one of the wealthiest in the city, commissioned Antoni Gaudí to construct a large building in Passeig de Gràcia, where a great many of the modernist buildings that characterised Barcelona were concentrated. Gaudí, born in Reus, as was Mrs. Milà, was the most prestigious architect of the time, having been the author of the Palau Güell, the Casas Vicens, Calvet, Batlló and Bellesguard, the Theresan College, the church of the Güell industrial village, the Temple of the Sagrada Familia, and of Park Güell.

The new building, completed between 1906 and 1912, was conceived by Gaudí as the body of an animal in which the numerous columns were the bones and the stone facade the skin. In this way, the facades were no longer the master walls that supported the building, as was common until then, but the structure of columns that withstood everything, and the facades, freed from their structural function, were the clothes. These clothes, which in theory could be put on and taken off, are what give character, expression and interest to the building.

←
LA PEDRERA,
SOURCE OF INSPIRATION
FOR ARTISTS

"THE PROJECTING ELEMENTS
SHOULD BE COMBINED WITH
THE RECESSES, SO THAT EACH
CONVEX ELEMENT IS
COUNTERED BY A CONCAVE
ONE, TO EACH PART OF LIGHT,
A SHADED ONE" Antoni Gaudí

IN THIS BUILDING GAUDÍ
FULFILLED THE AMBITION,
BEFITTING HIS TIME, OF
BRINGING TOGETHER ALL
THE ARTS IN ONE WORK,
AS A SUPREME OBJECTIVE
OF ARTISTIC CREATION

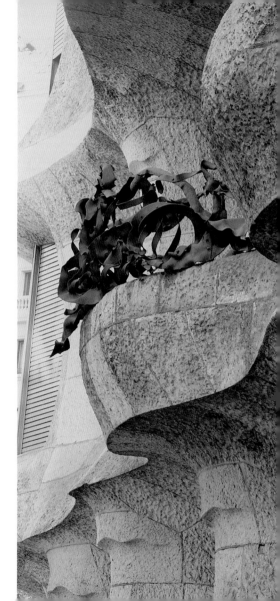

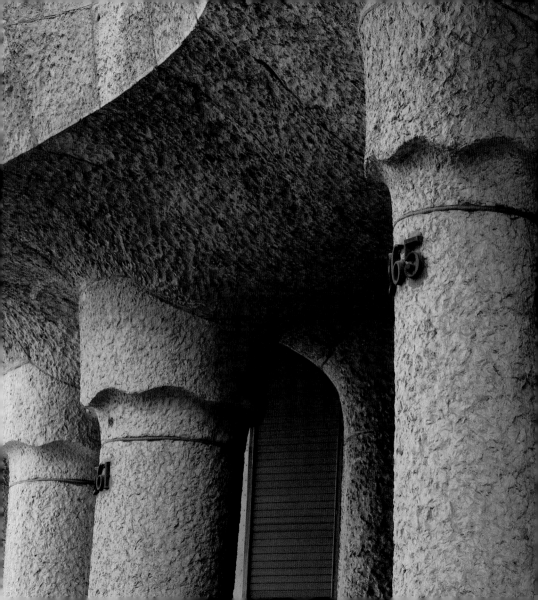

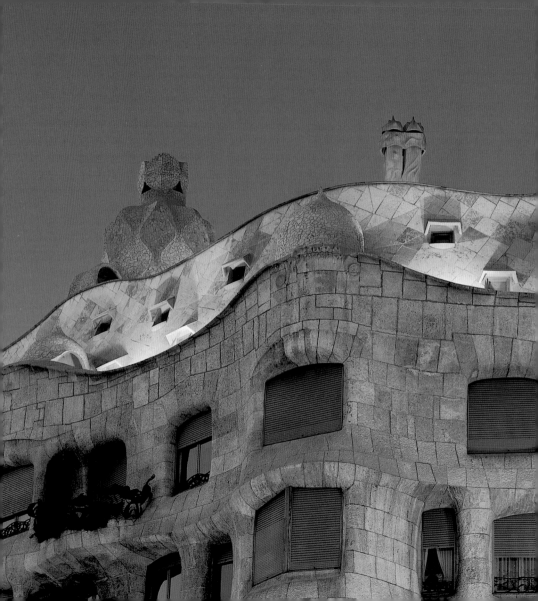

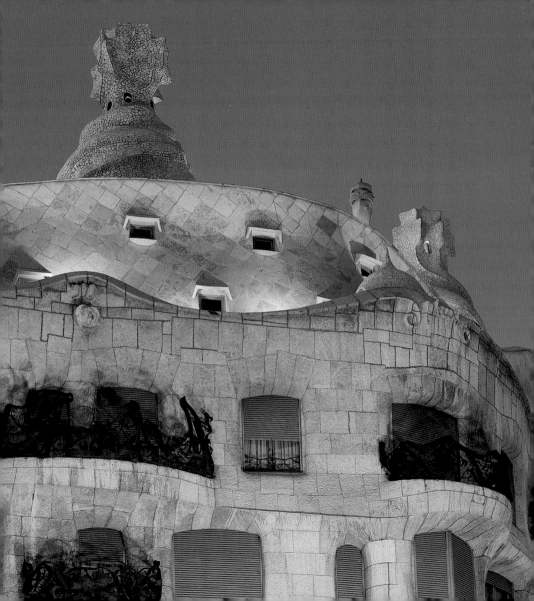

LA PEDRERA HAS
TRANSCENDED ITS ORIGINAL
FUNCTION OF A RESIDENTIAL
BUILDING TO BECOME A
VERITABLE CULTURAL CENTRE,
THE SETTING FOR MANY PUBLIC
EVENTS, THANKS TO THE
EFFORTS MADE TO THESE ENDS
BY THE CAIXA CATALUNYA

IN OCTOBER 2001 THE
FUNDACIÓ TERRITORI
I PAISATGE COMMEMORATED
WORLD BIRD DAY BY ADORNING
THE BUILDING WITH OVER ONE
HUNDRED REPRODUCTIONS
OF DIFFERENT SPECIES

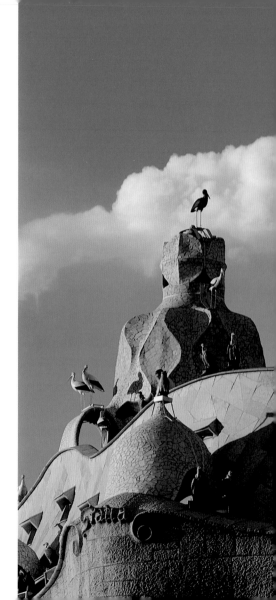

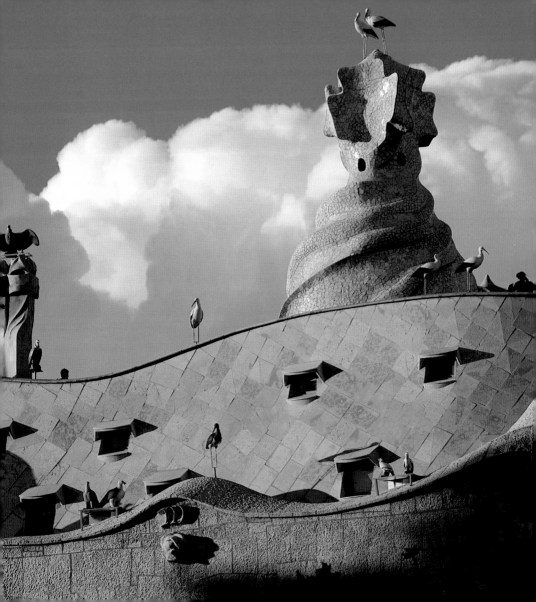

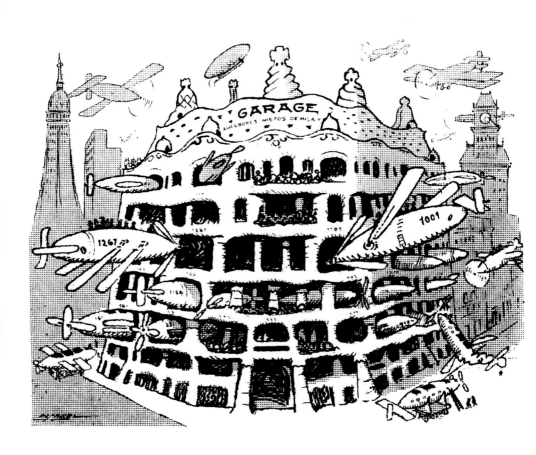

COMIC STRIP BY PICAROL
PUBLISHED IN "L'ESQUELLA DE
LA TORRATXA" IN 1912, IMAGINING
THE FUTURE OF LA PEDRERA AS
AN AIRCRAFT HANGAR

→
DURING THE FESTIVAL TITLED
"LA PEDRERA, MIRROR OF A
CENTURY", HELD ON THE 2ND OF
JULY 1998, THE THEATRE GROUP
"ELS COMEDIANTS" STAGED
PICAROL'S COMIC STRIP

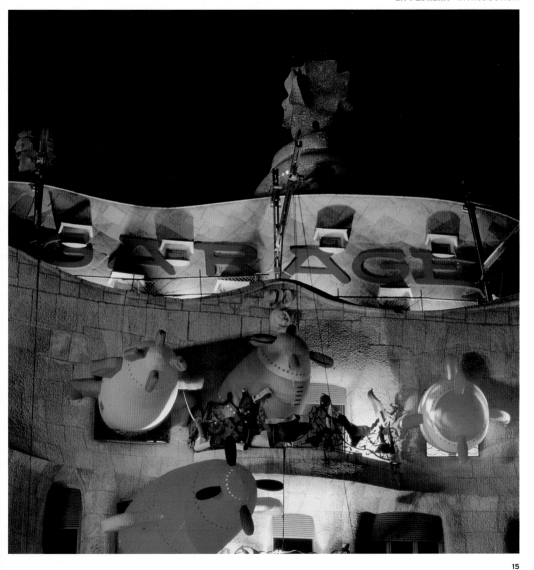

THE GIANT PUPPET OF THE
FRENCH THEATRE COMPANY
"ROYAL DE LUXE" CHOSE THE
TERRACE OF LA PEDRERA TO
SPEND A NIGHT IN BARCELONA

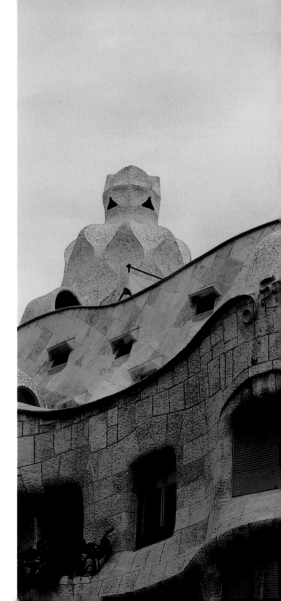

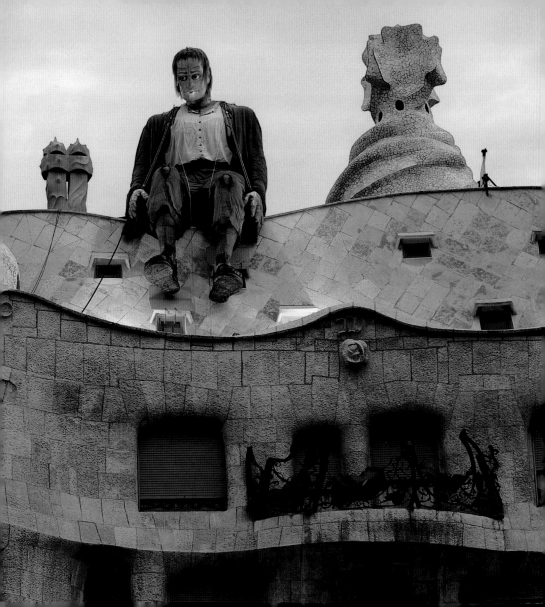

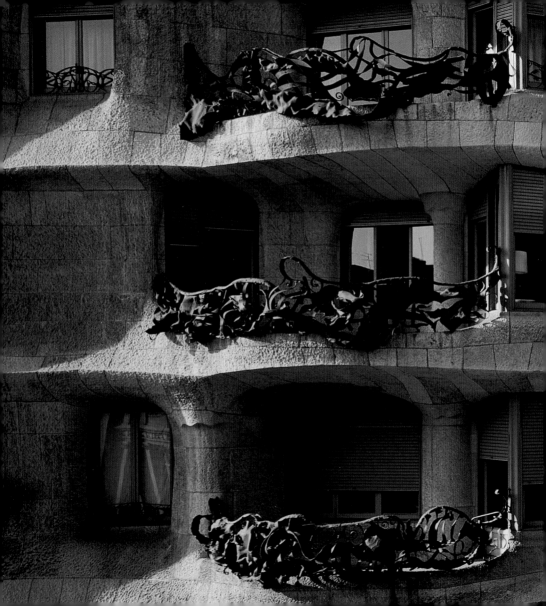

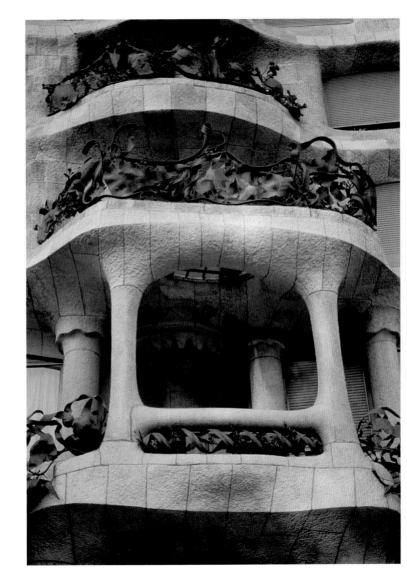

→
GALLERY OF THE MAIN FLOOR
OF THE CASA MILÀ

→
SHELL OVER THE ENTRANCE
OF THE MAIN GALLERY

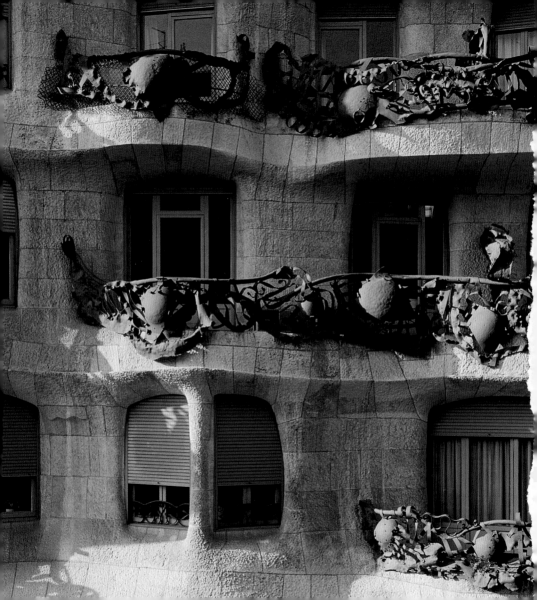

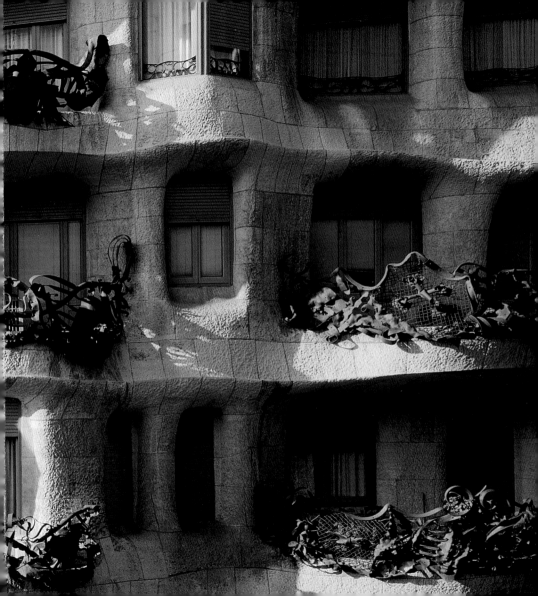

Waves of stone

The facade of this stone building undulates like the waves in the sea. Here the stone is as soft as water and the water as hard as stone. On it, Gaudí was able to represent *Metamorphoses* by the Latin poet Ovid, a work explaining the mythological creation of the world. "In the beginning all was Chaos, when all things soft were hard and hard things soft, and hot and cold were mixed together".

In La Pedrera the series of waves is almost total. The facade is undulated from top to bottom, from one side to another, from front to back, and the same occurs in the attics and terrace rooftops, and even on the walls of the rooms. It is a building unique in the world. Gaudí wanted to show that if all the building is in movement it is because it is alive, like an organism, like a living being. Gaudí was, therefore, an architect-alchemist, for who the material is something living: stone is water, iron on the balconies are animals and plants... the three kingdoms, animal, vegetable and mineral, co-exist, mix with each other: they are one and the same.

←
FACADE OF LA PEDRERA

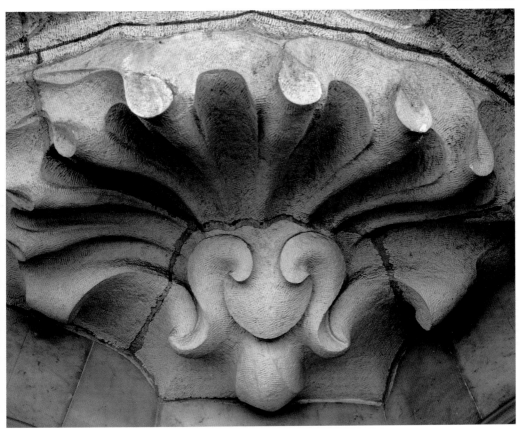

LA PEDRERA IS AN ENORMOUS
BUILDING-CUM-SCULPTURE
SUPPORTED BY A SKELETON
OF IRON THAT WITHSTANDS ITS
WEIGHT AND FREES THE WALLS
AND PARTITIONS FROM LOADS IN
AN ARCHITECTURAL PRECEDENT
THAT SOME YEARS LATER LE
CORBUSIER CALLED "FREE PLAN"

P. 26-27
→
THE CASA MILÀ IS THE FOURTH
PIECE OF WORK BY ANTONI GAUDÍ
IN PASSEIG DE GRÀCIA. THE FIRST
THREE WERE THE FARMACIA
GIBERT IN 1879, THE REFORM OF
THE BAR TORINO IN 1902 –BOTH
HAVING DISAPPEARED–AND THE
CASA BATLLÓ, BUILT BETWEEN
1904 AND 1907
→
ON THE UPPER PART OF THE
FACADE IS THE INSCRIPTION IN
LATIN: "AVE GRATIA PLENA
DOMINUS TECUM"

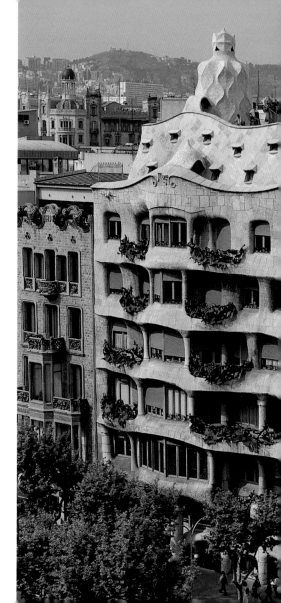

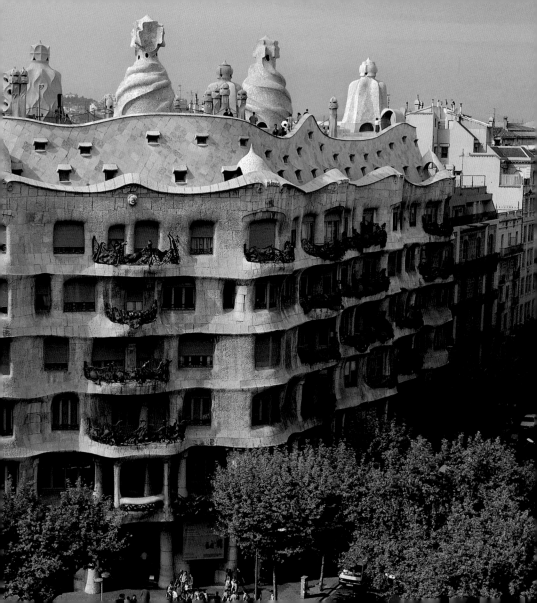

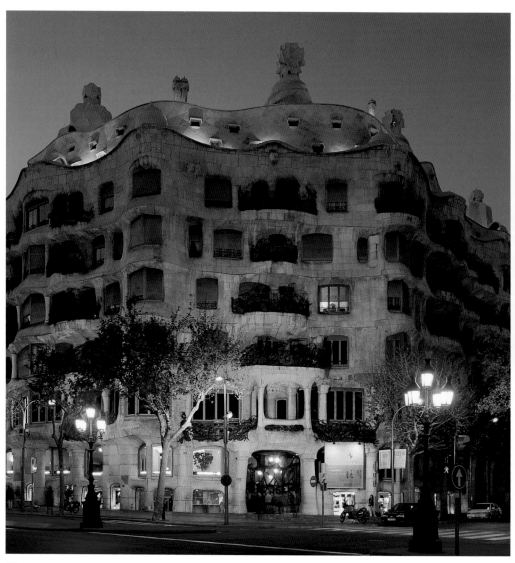

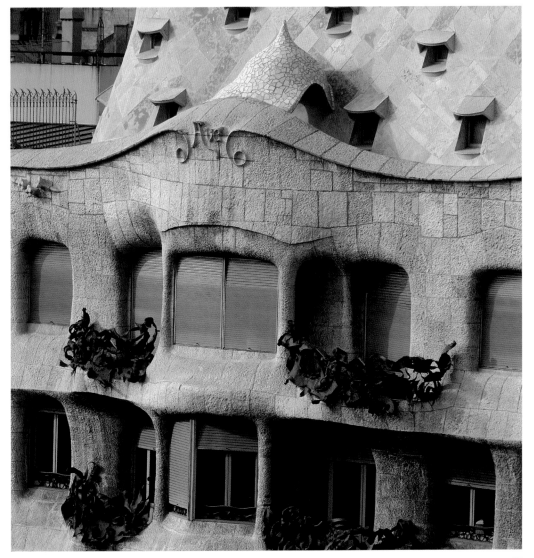

THE MODERNIST PAINTER
RUSIÑOL JOKED BY SAYING
THAT IN THIS HOUSE THE MILÀ
FAMILY WOULD NOT BE ABLE TO
HAVE A DOG, BUT THAT THEY
COULD HAVE A SNAKE

CÉSAR MARTINELL, DISCIPLE OF
GAUDÍ AND SCHOLAR OF HIS
WORK, REFERRED TO LA
PEDRERA AS "THE BIGGEST
ABSTRACT SCULPTURE IN
EXISTENCE "

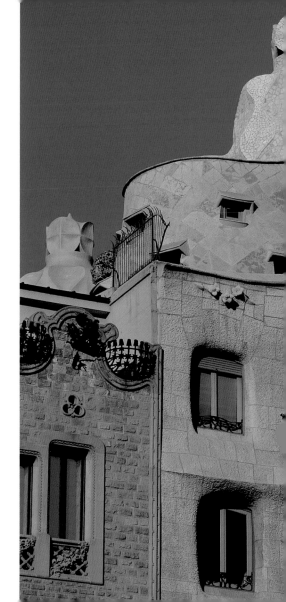

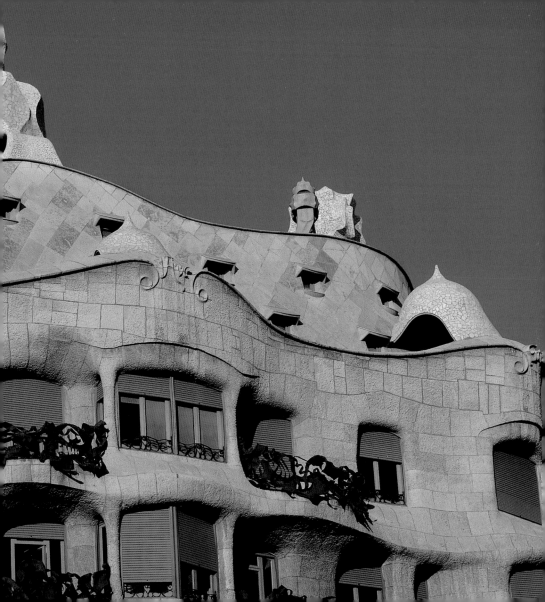

→

THE STONE USED ON THE FACADE
OF LA PEDRERA CAME FROM THE
QUARRIES OF VILAFRANCA DEL
PENEDÉS

→

ALONGSIDE THE INSCRIPTION
APPEARS THE "M", MONOGRAM
OF MARÍA, AND SYMBOLS SUCH
AS LILIES OR THE ROSE, AN
ELEMENT THAT GAUDÍ GAVE
SPECIAL IMPORTANCE TO BY
MAKING THE SCULPTOR DO
SEVERAL RETOUCHES TO THE
PIECE BEFORE HE WAS FULLY
SATISFIED

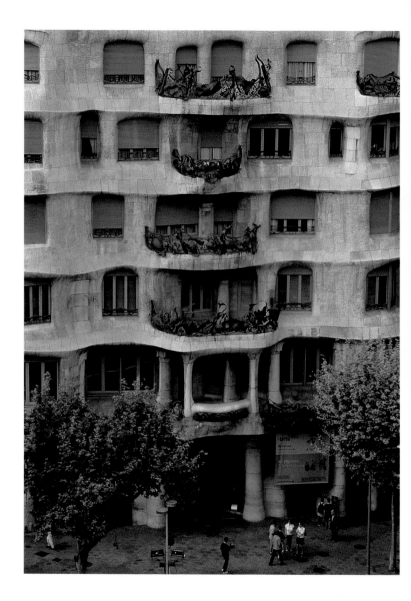

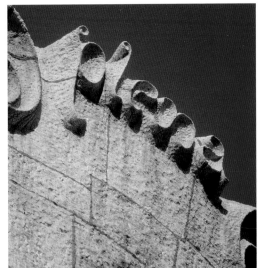

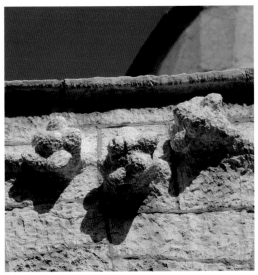

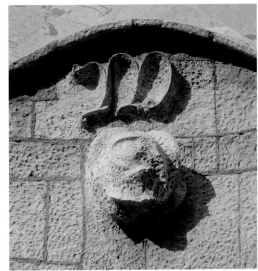

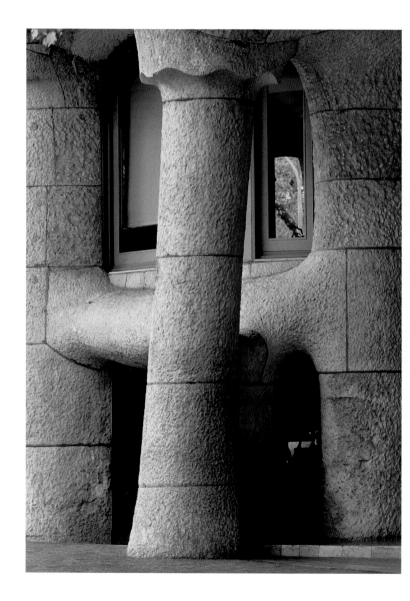

→
A COUNCIL INSPECTOR
REPORTED ONE OF THE
COLUMNS BECAUSE IT INVADED
THE PAVEMENT. ON FINDING
OUT, GAUDÍ SAID THAT HE
WOULD CUT IT OUT AS IF IT
WERE A CHEESE, FOLLOWING
THE LINE MARKED BY THE
REGULATIONS, AND THAT HE
WOULD ENGRAVE AN
INSCRIPTION WHICH STATED
"COLUMN MUTILATED BY ORDER
OF THE COUNCIL"

→
"THE STONE PATINA, ENRICHED
BY CLIMBING PLANTS AND THE
BALCONY FLOWERS, WOULD
HAVE GIVEN A CONSTANTLY
RENEWABLE COLOURING TO
THE HOUSE"
Antoni Gaudí

P. 34-35
→
BALCONY WITH THE SAGRADA
FAMILIA IN THE BACKGROUND

→
WHEN THE RAILS OF THE
BALCONIES HAD STILL NOT
BEEN PLACED, A HUMORIST
COMPARED THE PIECES OF IRON
WITH THE REMAINS OF A TRAIN
ACCIDENT

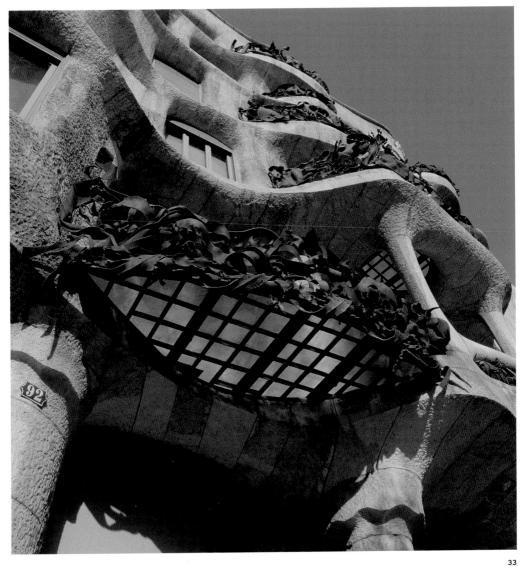

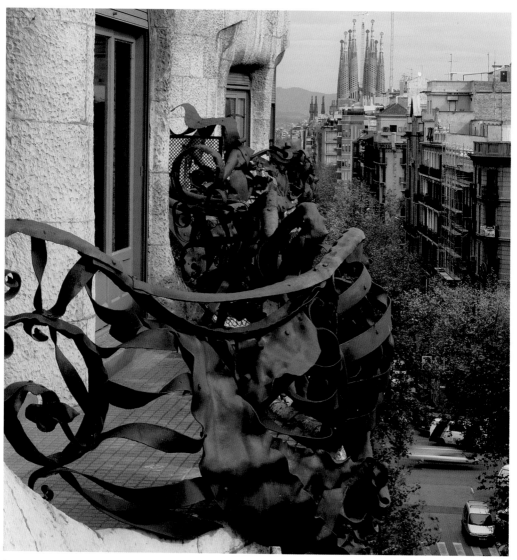

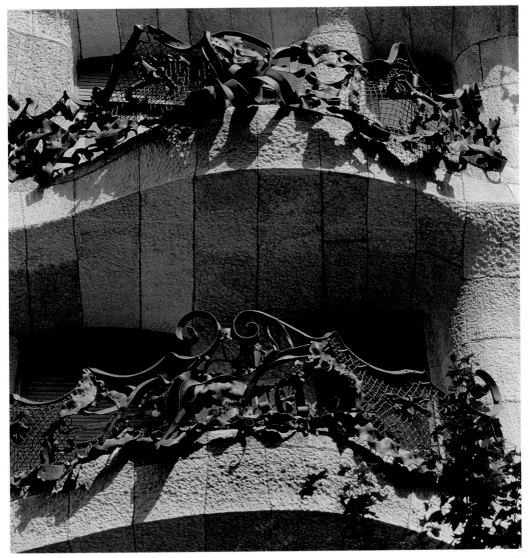

→
DESPITE THE DOMINATING
ABSTRACTION OF THE
BALCONY FORMS, FIGURATIVE
DETAILS APPEAR IN SOME,
SUCH AS THIS MASK

→
DETAIL OF THE FIRST BALCONY,
CAST UNDER THE DIRECT
SUPERVISION OF GAUDÍ AND
WHICH SERVED AS A GUIDE
FOR JUJOL TO MAKE THE
OTHERS. A CLOSE LOOK
REVEALS A STAR, A CROSS,
A BIRD AND TWO FLOWERS

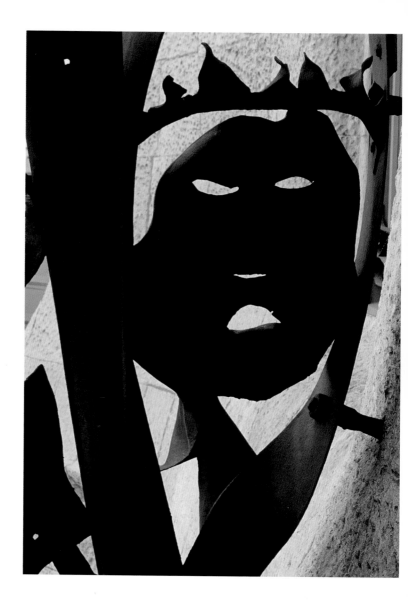

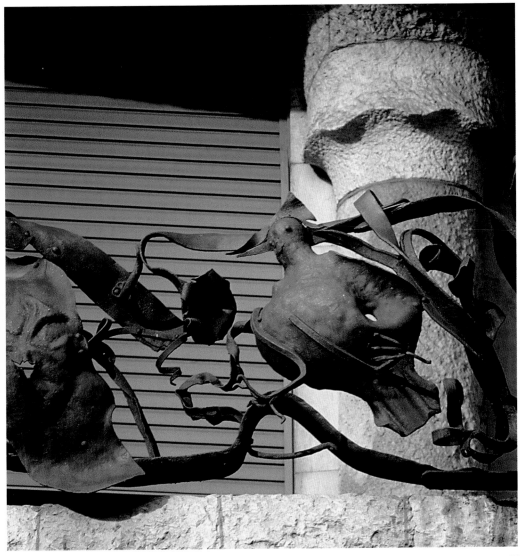

ON THE GRILLES OF THE
BALCONY THE ART OF FORGING
ATTAINS A SURPRISING
STYLISTIC FREEDOM

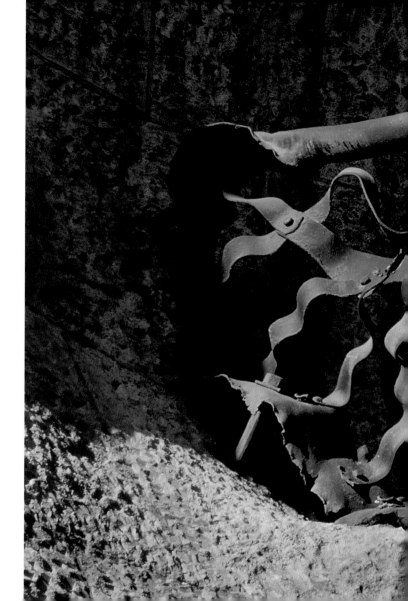

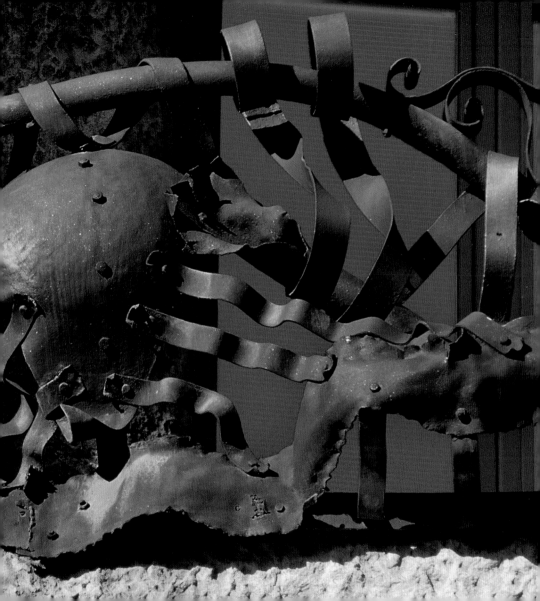

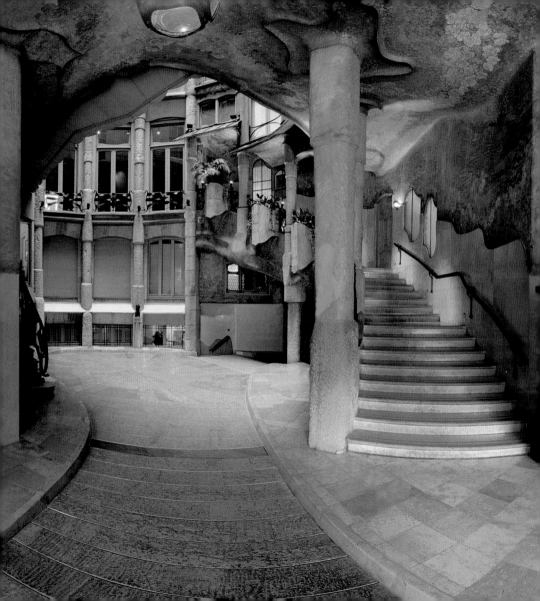

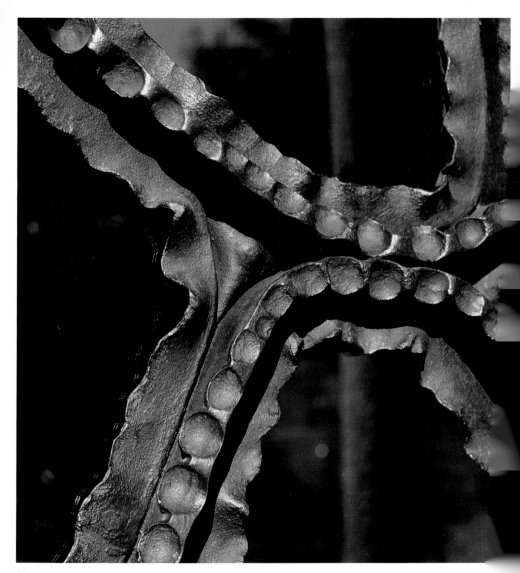

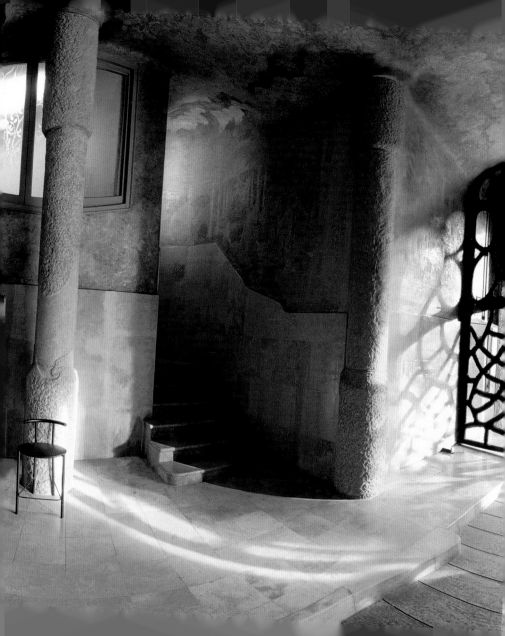

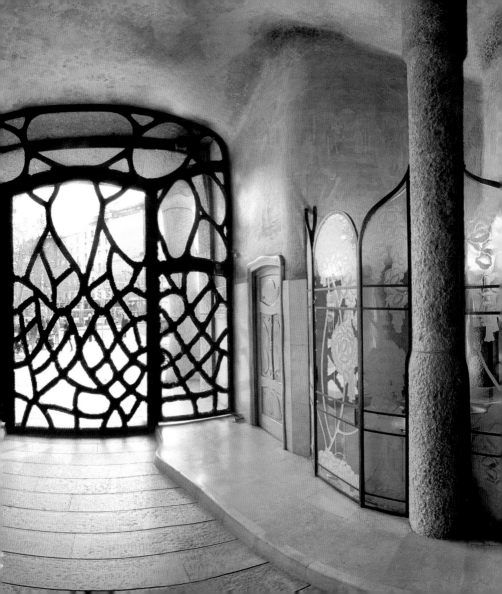

A world of appearances

To show that everything changes, in La Pedrera as in nature, on the walls of the vestibule of Passeig de Gràcia there are some tapestries reproduced from the Royal Palace of Madrid with themes taken from the book of *Metamorphoses*. On one can be seen the nymph, Syrinx who, in order to avoid the god Pan's relentless pursuit, is transformed into the reeds that Pan himself used to make the instrument he called the syrinx, in her honour, Pan's pipe. In another, Vertumnus, the god of autumn, appears represented with the different attributes of different trades in order to find one that will make Pomona, the elusive goddess of fruit, fall in love with him.

Both myths demonstrate that reality is deceitful. These games of changes and deceit continue along the stairway that leads to the main floor: some stone columns have their reflection painted on the opposite wall, signifying that the truth may be false, and reality, a dream. If the legends are taken from Ovid, these reflective tricks may be inspired by the drama by Calderón de la Barca *Life is a dream*.

360º PANORAMA OF
THE PASSEIG DE GRÀCIA
ENTRANCE

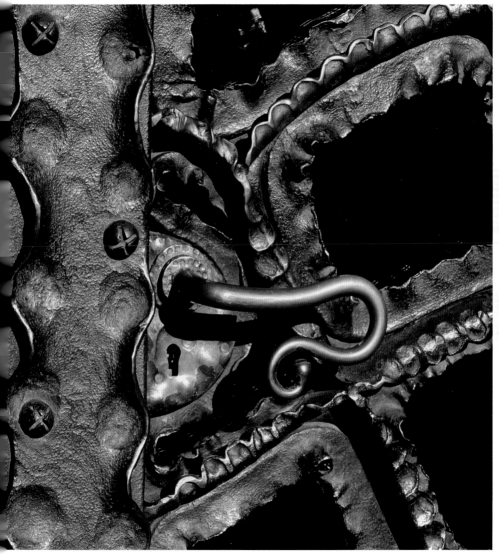

, 44-45

HE MARKS ON THE VESTIBULE
OORS GIVE THE IRON THE
UALITY OF A SOFT HAND-
OULDED MATERIAL

ESTIBULE DOOR OF PASSEIG
E GRÀCIA

, 48-49

AUDÍ WANTED THE SHAPE
OF THE PIECES ON THE GRILLES
O COPY THE MOVEMENT OF A
ILK RIBBON THROWN INTO THE
IR. IN THIS WAY, A HEAVY
ATERIAL WAS ABLE TO GIVE
HE SENSATION OF LIGHTNESS
ND MOVEMENT

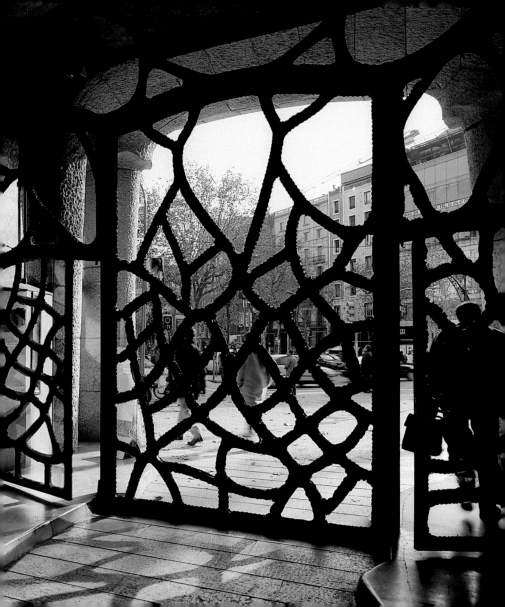

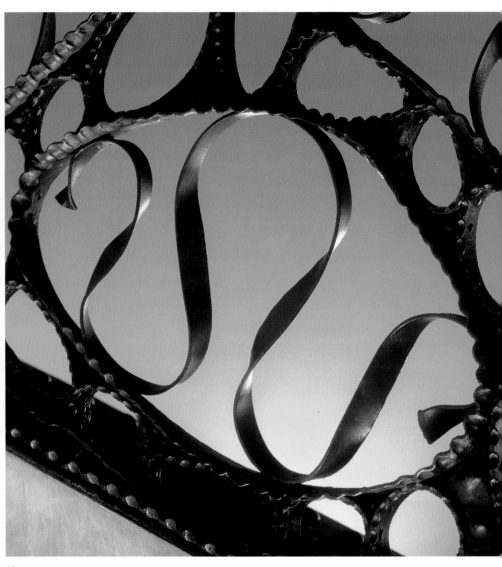

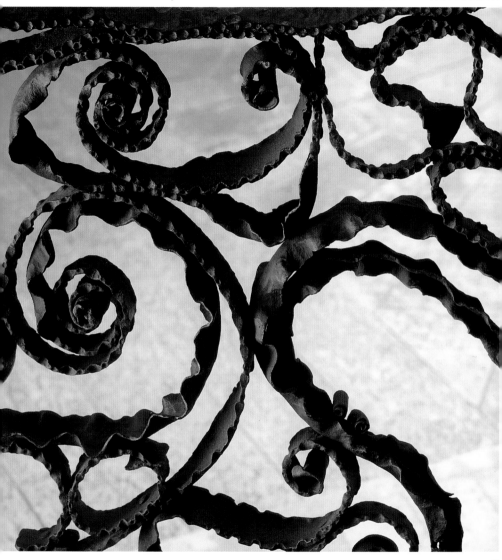

E DOORS ARE MADE UP OF
NDOWS OF DIFFERENT SIZES
AT ALLOW LIGHT TO ENTER
E VESTIBULES

52-53

E GRILLES ARE UNDULATING
BBONS JOINED BY RIVETS

ATER LILIES ENGRAVED IN
E PORTER'S CABIN

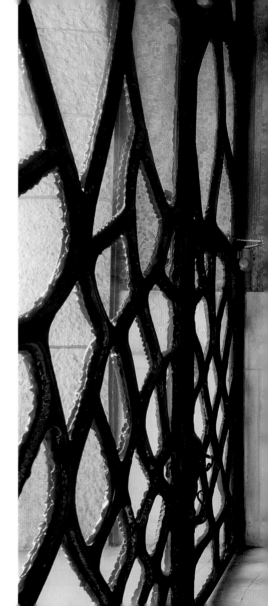

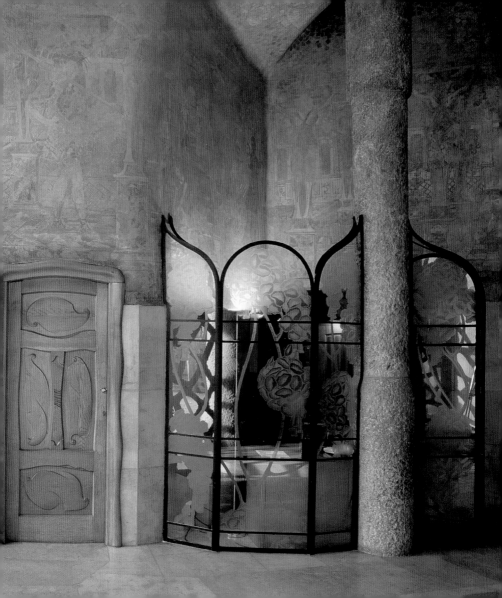

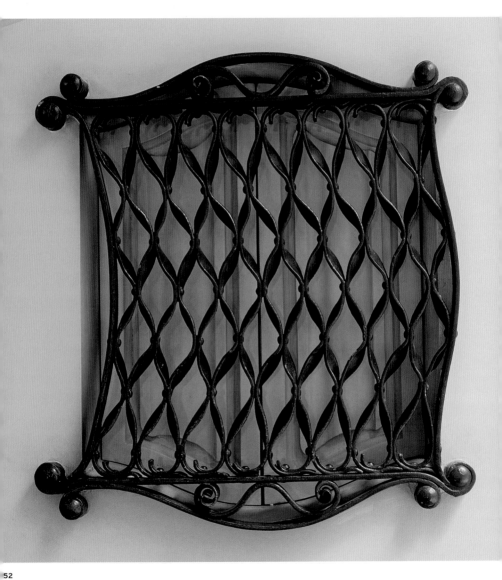

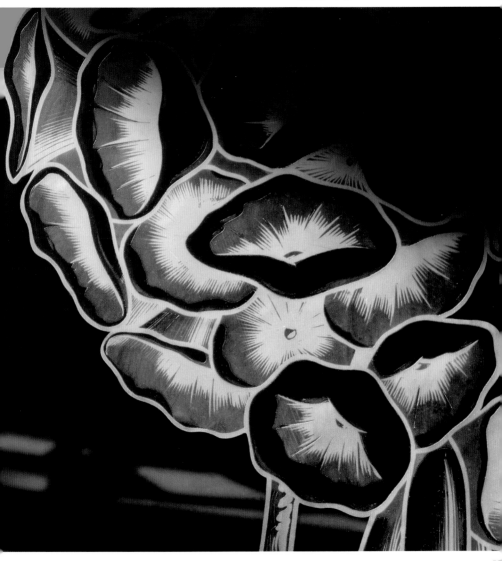

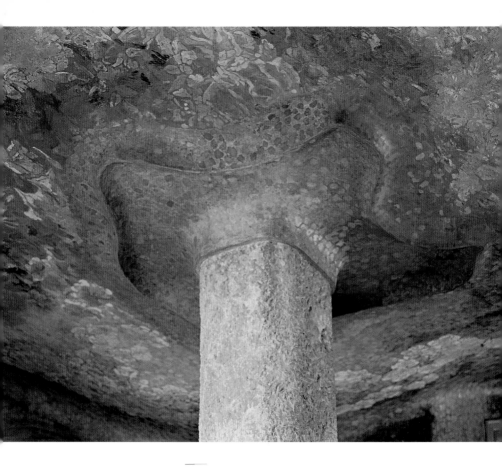

E HARDNESS OF THE STONE
THE COLUMN BLENDS IN WITH
E SOFTNESS OF THE COLOUR
THE CEILING PAINTINGS IN A
RFECT COMBINATION BETWEEN
RM AND COLOUR

→
COLUMNS AND FLOWER BOXES IN
THE ENTRANCE STAIRWAY TO THE
FIRST FLOOR

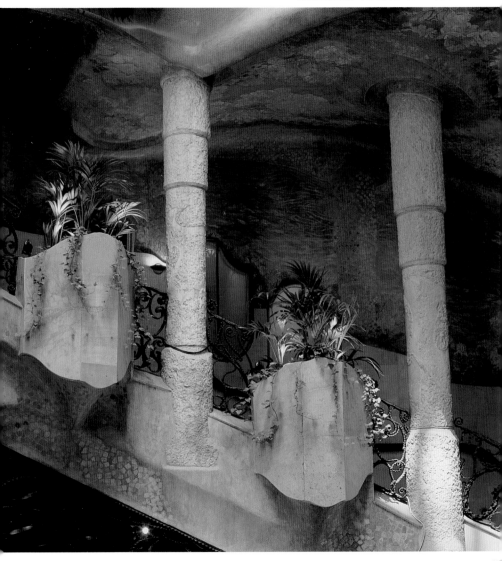

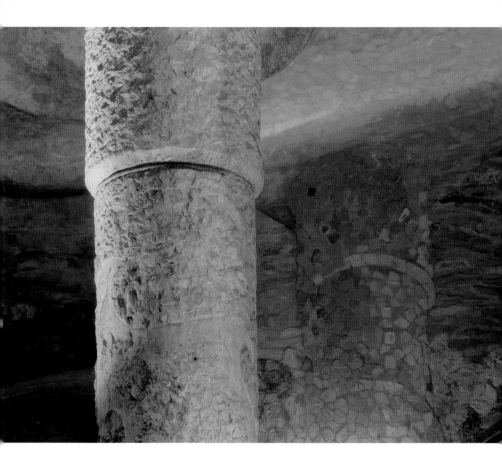

S IF IT WERE A REFLECTION,
PPOSITE THE REAL COLUMN IS
NOTHER PAINTED ONE

→
VESTIBULE LANTERN

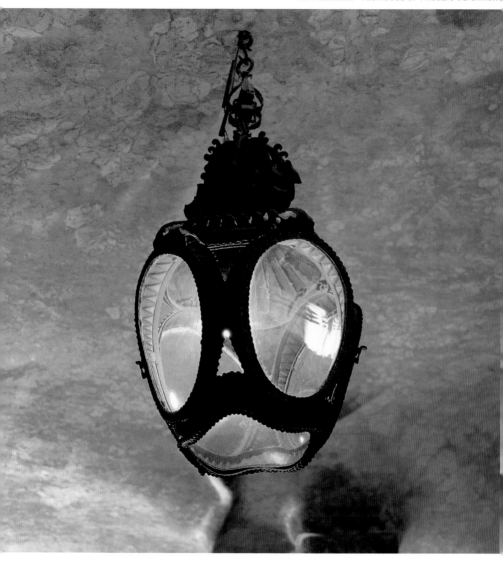

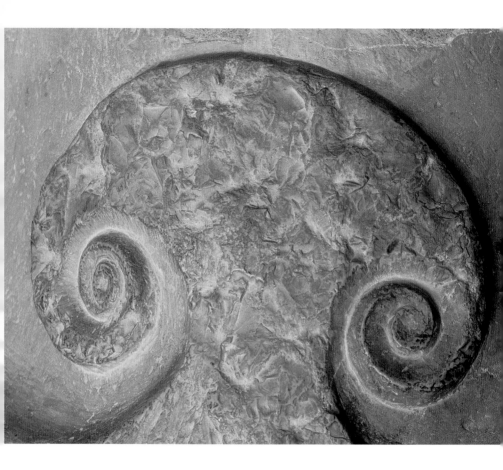

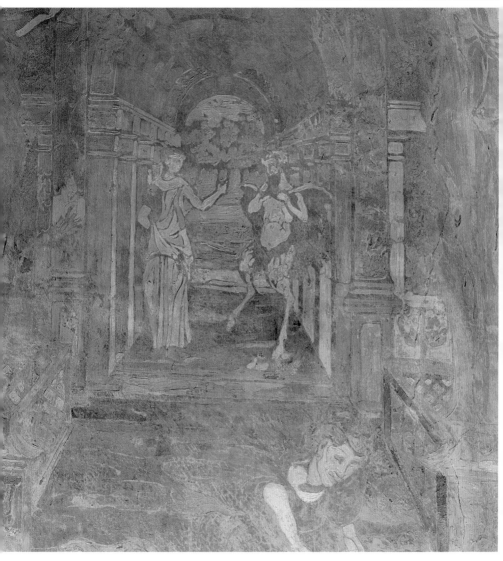

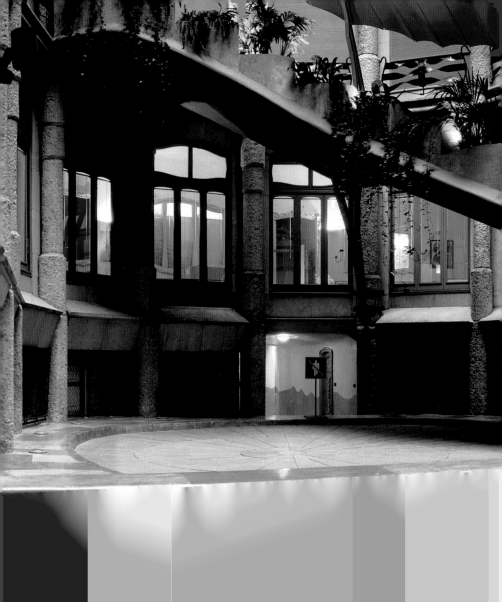

Symbolic reality

In this vestibule there are other mural paintings that help us understand the generative idea behind La Pedrera. In the painting alongside the entrance door, the prophetess Cassandra states that Troy will be destroyed: that which is will not be. In the painting on the ceiling, you can see, though with a little difficulty, two women on either side of the throne of Romulus, founder of Rome, although Gaudí leaves the throne empty: that which was, is not. The vices of Anger and Greed are shown on the other murals. Gaudí alludes to traditional stories and legends by means of a symbolism that insufflates them with new life, the aim being to move on from reality towards the higher sphere of profound experience.

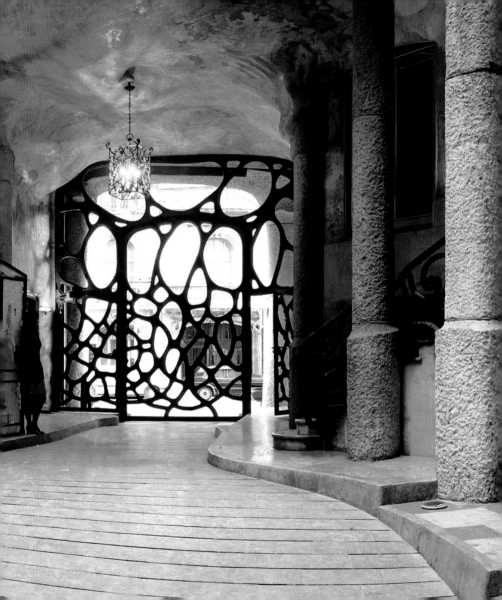

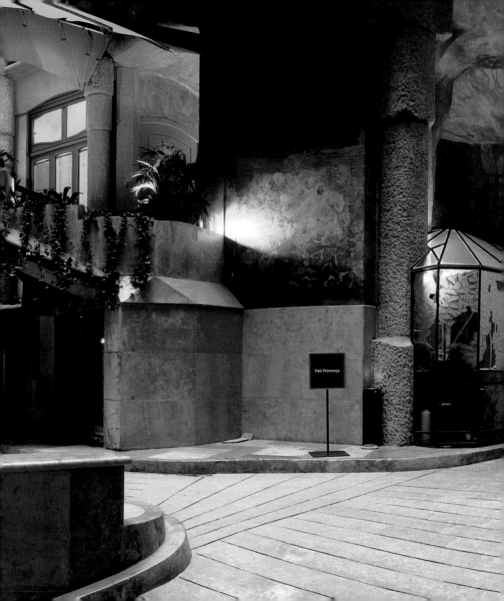

→
ENTRANCE DOOR TO THE
VESTIBULE OF CARRER
PROVENÇA

→
CAST IRON RAIL OF THE
SERVICE STAIRWAY

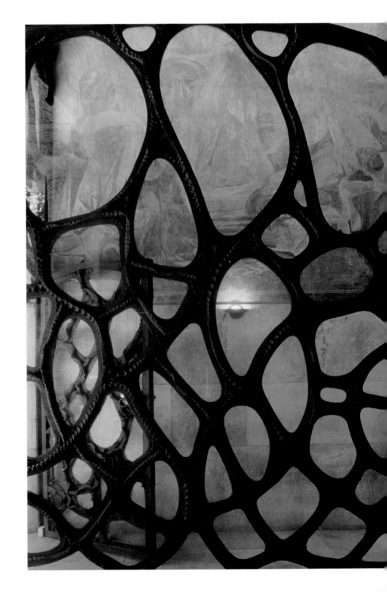

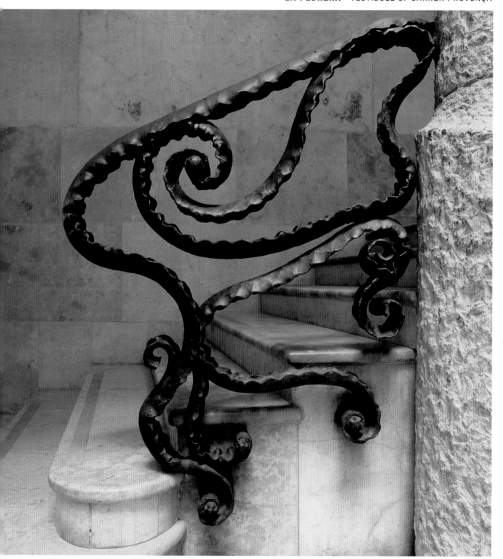

THE DOORS OF THE CASA MILÀ,
WHICH SEEM TO IMITATE THE
CELLULAR STRUCTURE OF AN
ORGANISM, ARE CONSIDERED,
ALONG WITH THE BALCONIES,
AS A PRECEDENT
OF ABSTRACT ART

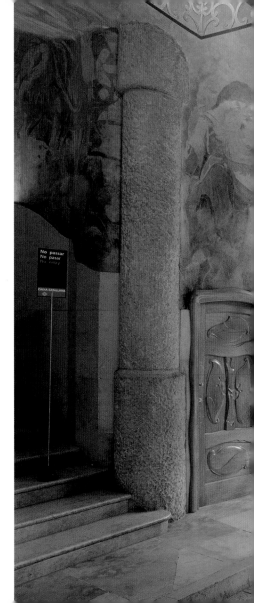

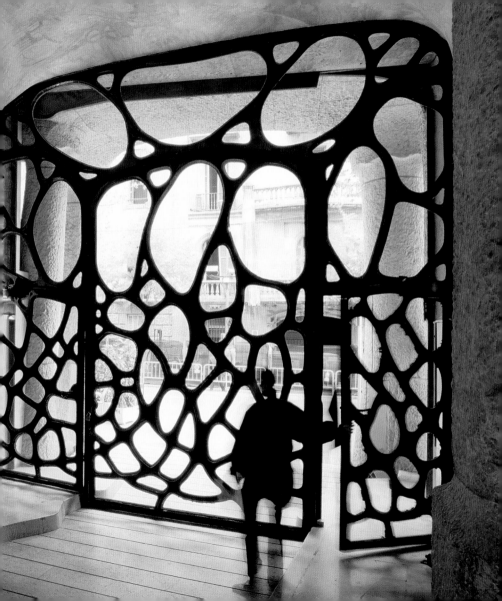

THE MURAL PAINTINGS ARE
INSPIRED BY SOME 16TH
CENTURY TAPESTRIES OF A
MYTHICAL SUBJECT MATTER.
IN THE IMAGE ON THE RIGHT,
CASSANDRA ANNOUNCES TO
THE DISBELIEVING PEOPLE OF
TROY THE DESTRUCTION OF
THE CITY. ON THE RIGHT, THE
FEMININE FIGURE OF GREED,
ONE OF SEVEN CARDINAL SINS

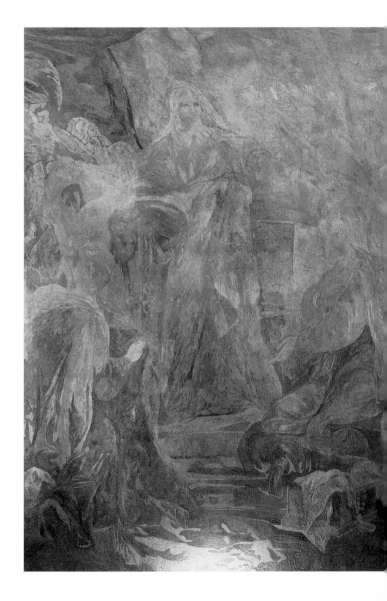

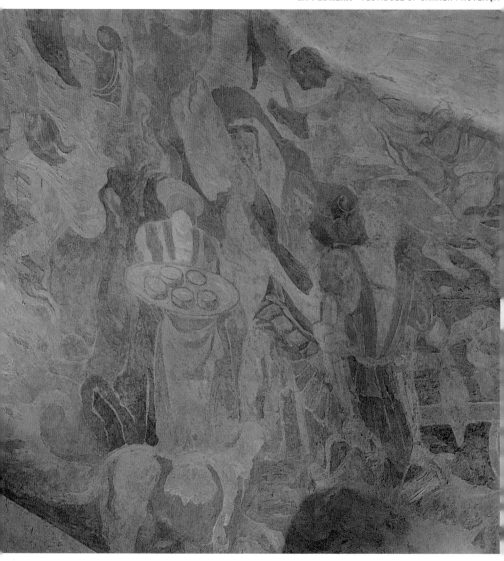

THE PAINTINGS WERE
RESTORED BETWEEN 1991 AND
1992. IN THE IMAGE A SCENE
FROM THE MURAL DEDICATED
TO ANGER

74-75

PASS PORTER'S CABIN
►
RELIEF WORK OF ORGANIC
AND GEOMETRIC FORMS IN
THE WOODEN DOORS

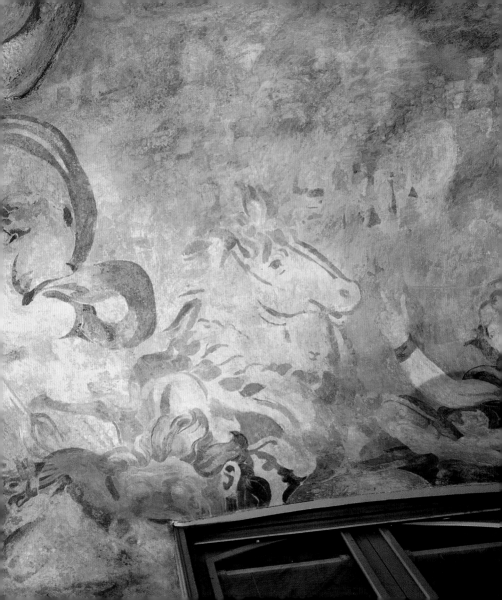

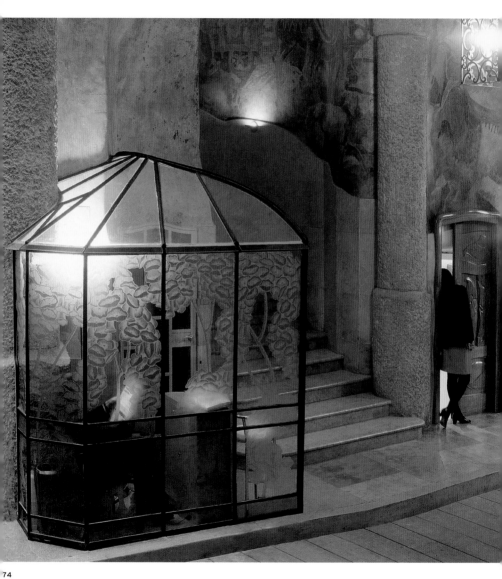

E BUILDING IS FORMED
OUND TWO LARGE
URTYARDS THROUGH
HICH LIGHT ENTERS INTO
L THE HOMES

78-79
►
E MURAL IN THE GALLERY
CING THE COURTYARD
A COPY OF THE FLEMISH
PESTRY TITLED "THE
RTUNE"

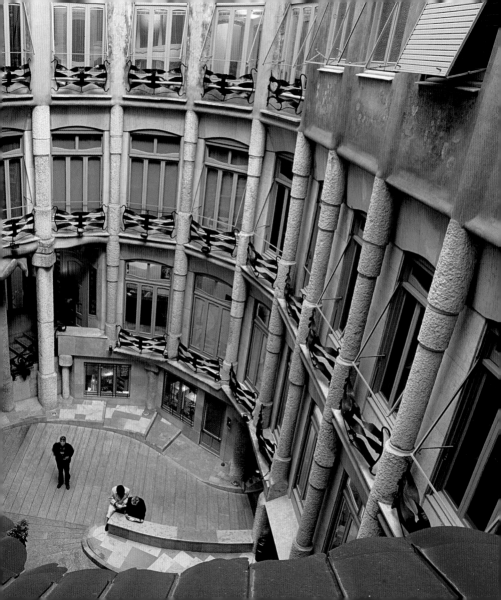

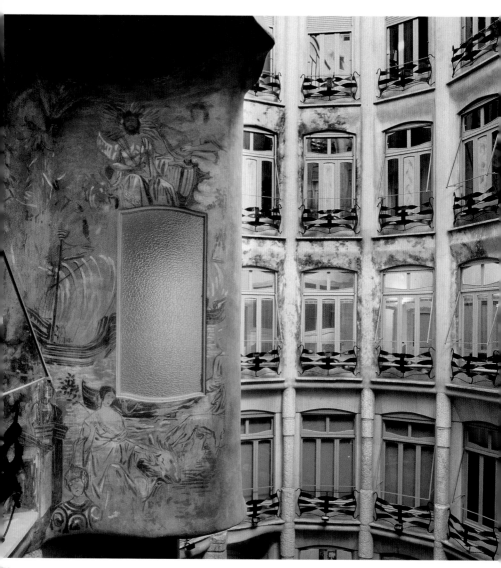

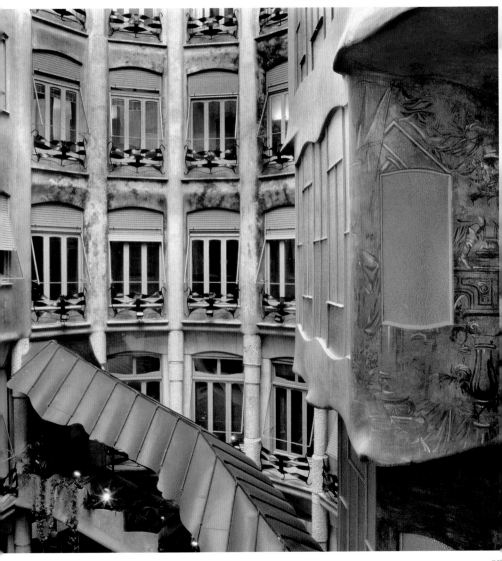

THE IMPORTANCE GAUDÍ
GAVE THE COURTYARDS
AS DISTRIBUTORS OF LIGHT
REACHES ITS ZENITH IN LA
PEDRERA, TURNING THEM INTO
VERITABLE INTERIOR FACADES,
BOTH IN TERMS OF THEIR SIZE
AND IN THE ARCHITECTURAL
APPROACH

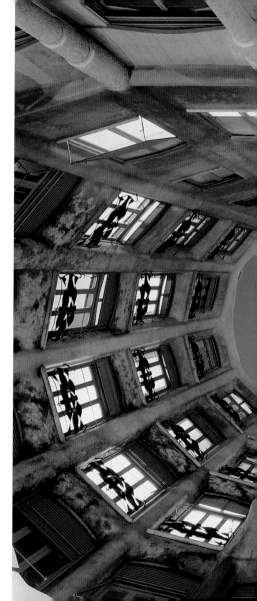

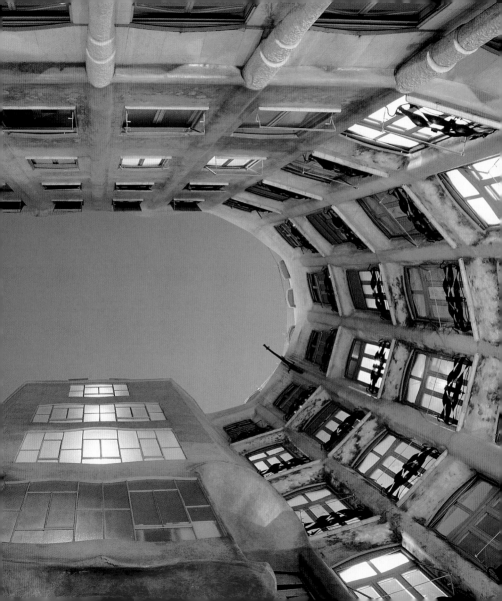

OURTYARD OF THE PASSEIG
E GRÀCIA VESTIBULE.
THE INITIAL PROJECT GAUDÍ
EIGHED UP THE POSSIBILITY
F CREATING A HELICOIDAL
AMP WHICH WOULD GO UP
HROUGH THE COURTYARDS
ND ENABLE CARS TO REACH
HE LANDINGS OF EACH
LOOR. THIS IDEA WAS NOT
DOPTED SINCE IT WAS
HYSICALLY IMPOSSIBLE, BUT
RAMP WAS BUILT TO THE
ASEMENT AND FITTED OUT
S A CAR PARK

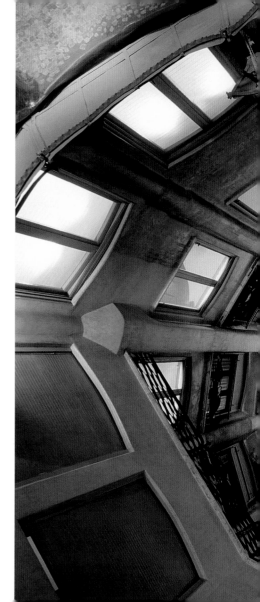

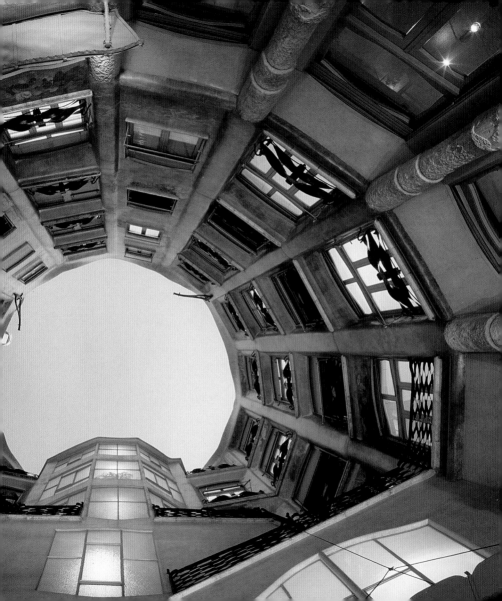

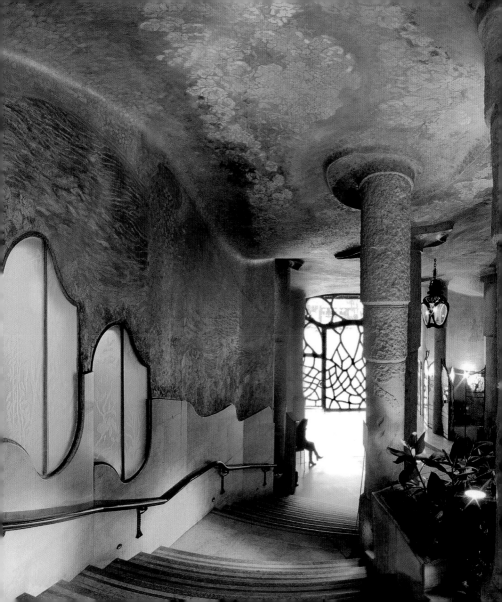

The main floor of the Milà family

In 1912 Gaudí completed the work on La Pedrera, and the Milà family were able to move into the first floor overlooking Passeig de Gràcia. The interior, today open to the public, has the peculiarity of being on two levels, thus enhancing the sensation of movement. In the original project all the walls were curved and the structure of the building permitted them to be moved, so that the size and shape of the rooms could vary. To increase this sensation of movement even further, Gaudí created ceilings that imitated the surface of a sea with waves seen from within, which would turn the inhabitants of the house into marine creatures, such as mythical newts and sea nymphs.

←
ENTRANCE STAIRWAY
TO THE FIRST FLOOR

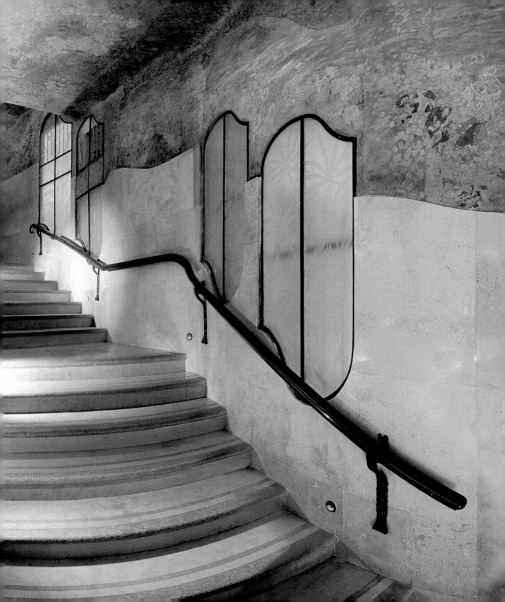

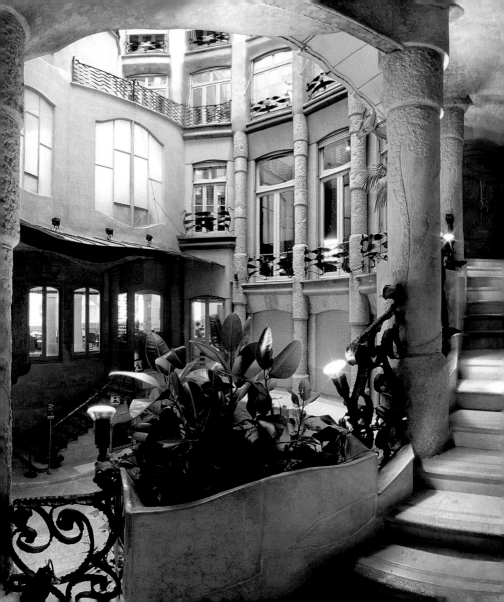

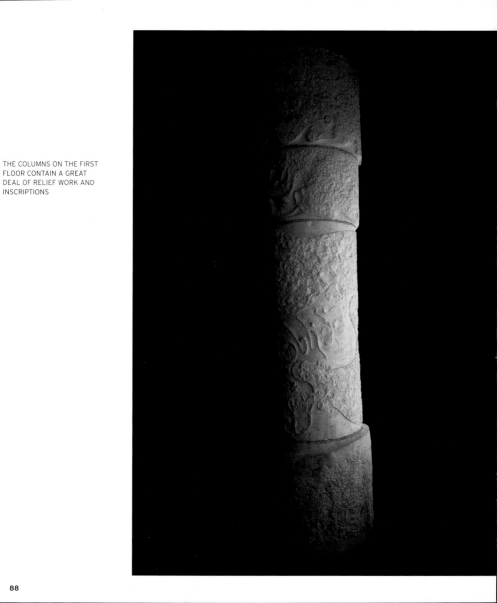

THE COLUMNS ON THE FIRST
FLOOR CONTAIN A GREAT
DEAL OF RELIEF WORK AND
INSCRIPTIONS

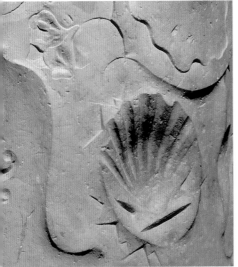

INTERIOR OF THE MAIN FLOOR.
THE OLD HOME OF THE MILÀ
FAMILY IS CURRENTLY AN
EXHIBITION ROOM OF THE
FUNDACIÓ CAIXA CATALUNYA

P. 92-93
→→
INSCRIPTIONS ON A COLUMN,
"PERDONA" AND "OBLIDA"
(FORGIVE, FORGET)

P. 94-95
→
BAS-RELIEF OF A TURTLEDOVE
ON A COLUMN ON THE FIRST
FLOOR
→
DETAIL OF THE CEILING ON THE
FIRST FLOOR

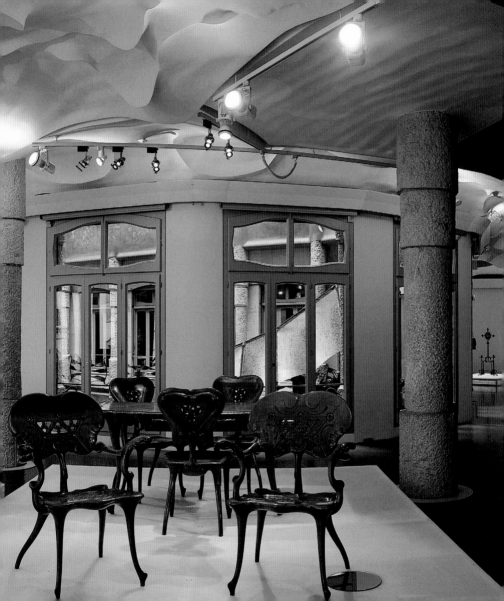

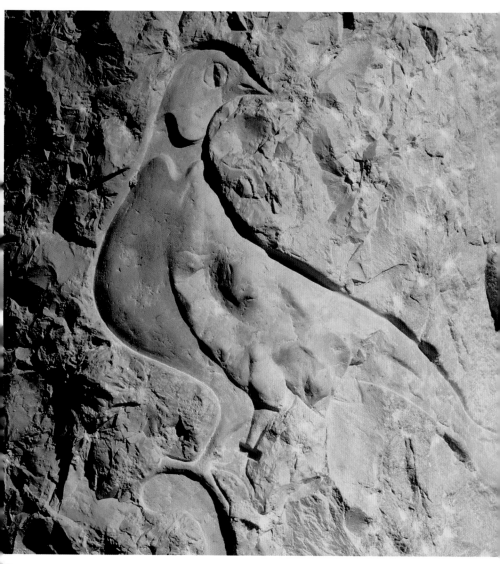

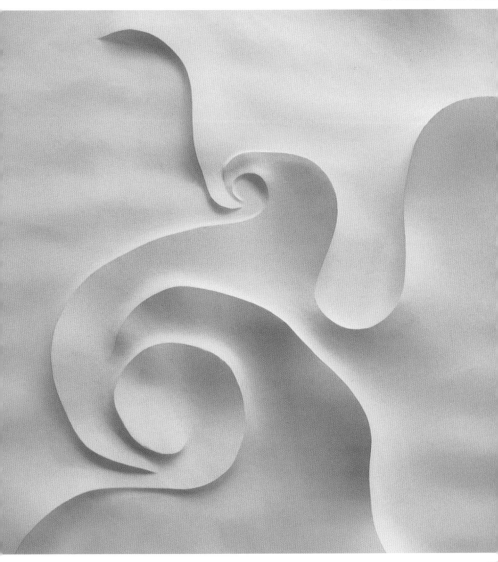

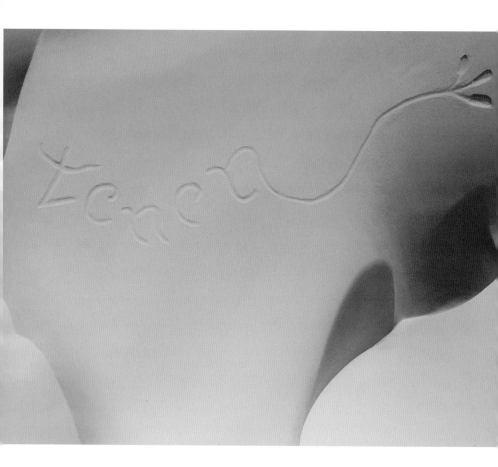

P. 98-99
→
SIGNATURE OF J.M. JUJOL
ON ONE OF THE CEILINGS
→
MONOGRAM OF MARÍA

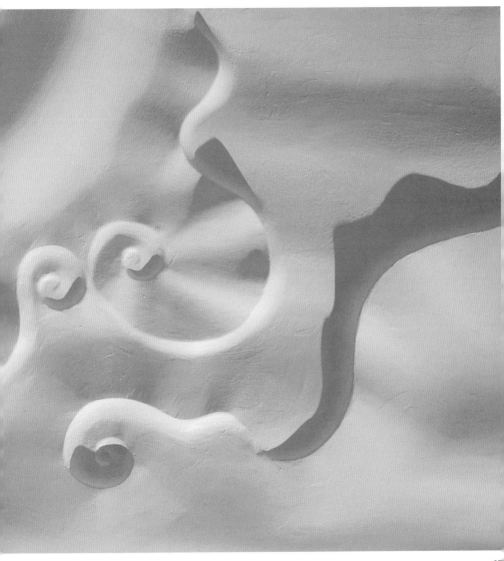

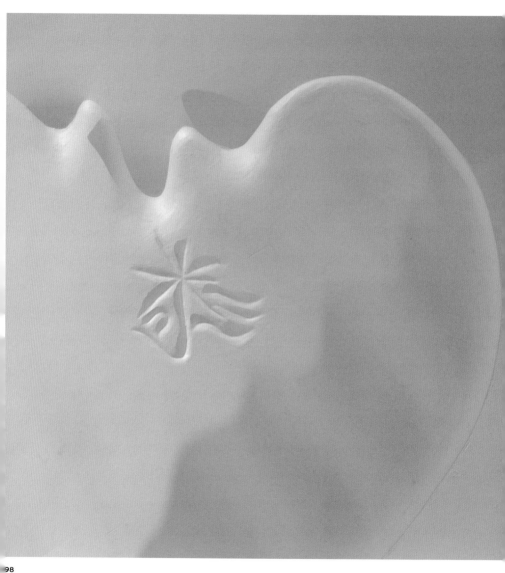

HIRLPOOLS ON THE CEILING
 THE MAIN FLOOR

102-103
→
N THE LINTELS OF THE
OORS OF ONE OF THE FLATS
 THE INSCRIPTION "AVE
ARIA" AS A WELCOME

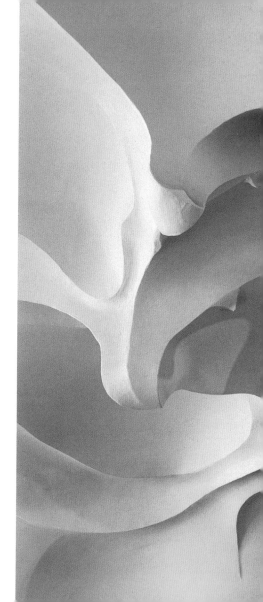

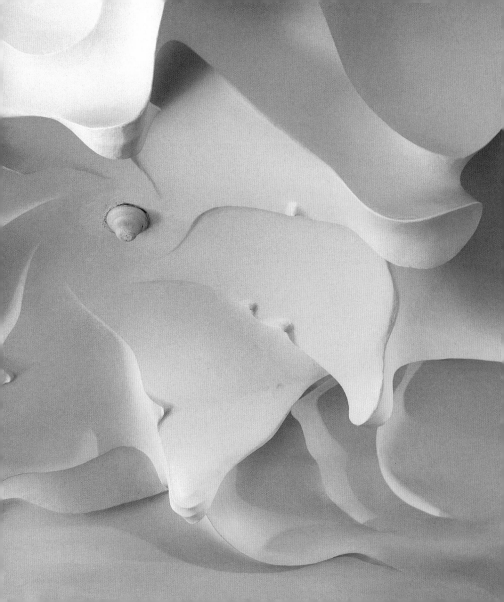

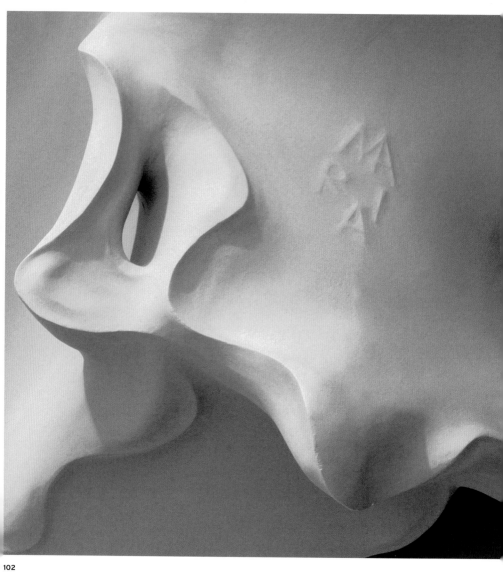

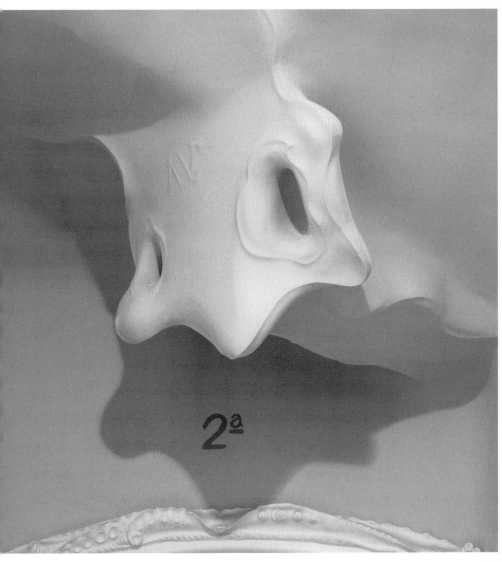

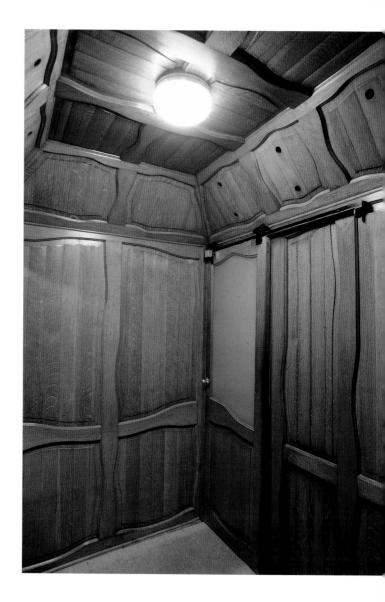

IN LA PEDRERA ENTRANCE TO
THE FLATS IS BY LIFT. GAUDÍ
ELIMINATED THE RESIDENTS'
STAIRWAY IN ORDER TO GAIN
SPACE IN THE COURTYARDS,
KEEPING ONLY THE SMALL
SERVICE STAIRWAY

→
WARPED SHAPES ARE
THE BASIS OF THE DOOR
AND WINDOW HANDLES IN
CONCORDANCE WITH THE
CURVES OF THE CEILINGS
AND DOOR AND WINDOW
FRAMES

The inside of the Dragon

The attic is one of the most extraordinary spaces created by Gaudí. Movement, shown as a *leitmotiv* of La Pedrera, is even more visible and pure here, with a succession of 270 arches of different heights in an undulating and winding sequence.

To make these brickwork arches Gaudí dropped a chain from wall to wall and lengthened it until achieving the desired arch form. The carpenters then converted this shape into wooden arches which were turned upside down so that the bricklayers could make them. This positive-negative interplay is one of the brilliant architect's most interesting processes.

If the attic of the Casa Batlló represents, at the high point of the facade, a dragon, in La Pedrera the dragon is interior and today's visitors walk around its inside. It is well worth observing, from the models of the different buildings created by the architect, and what makes up the Espai Gaudí exhibition centre, what the attic arches describe.

←
THE ATTIC

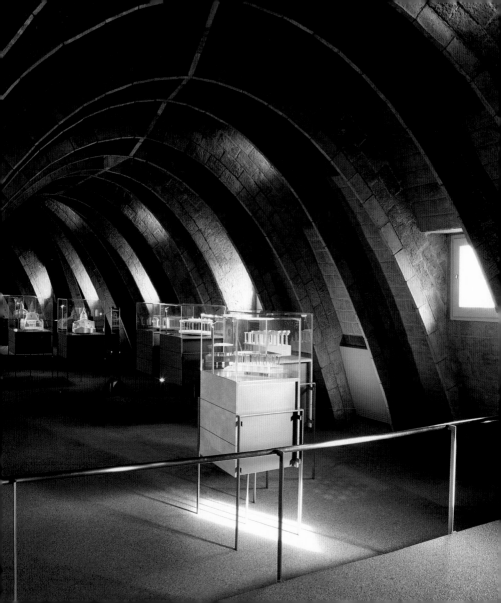

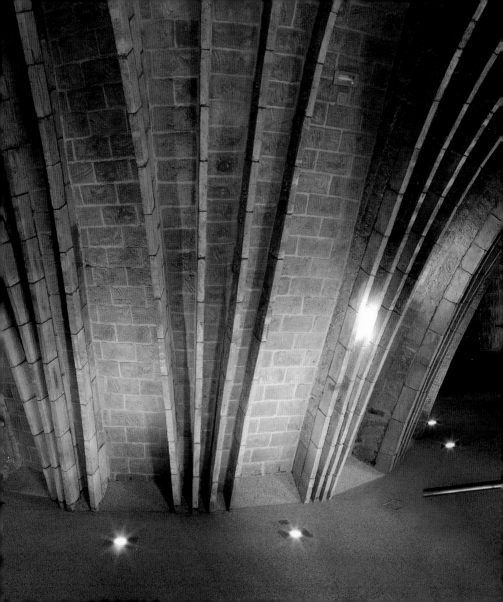

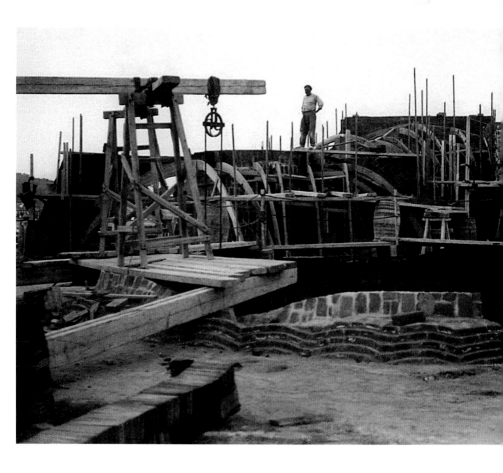

CONSTRUCTION PROCESS OF
THE ATTIC ARCHES

→
THE ATTIC FULFILLED THE DOUBLE
ROLE OF CONTROLLING THE
TEMPERATURE OF THE BUILDING
AND AS A SPACE FOR WASHING AND
DRYING. IN 1954 AND 1955 IT WAS
TRANSFORMED INTO A SERIES OF
APARTMENTS BY THE ARCHITECT
BARBA CORSINI. IT CURRENTLY
HOUSES THE "ESPAI GAUDÍ"

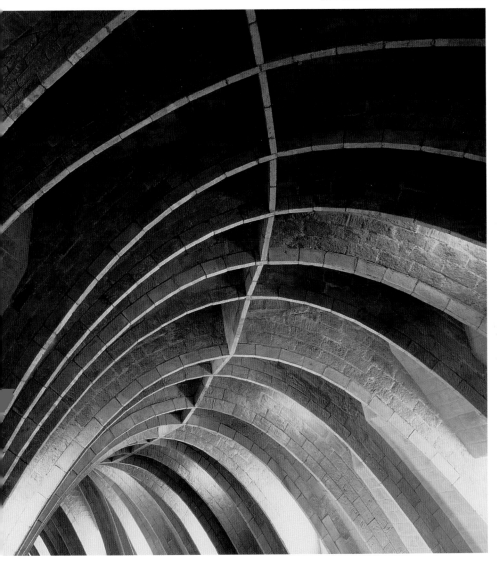

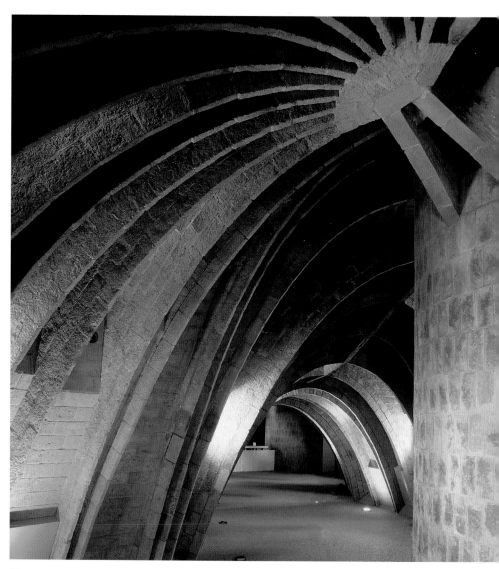

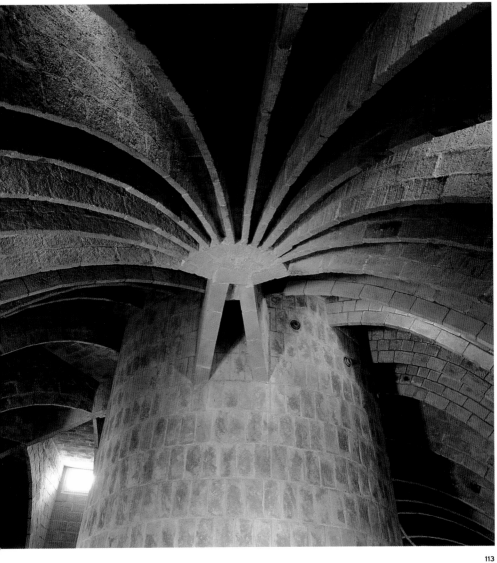

A SERIES OF BRICKWORK
ARCHES OF A CATENARY
STRUCTURE AND OF
DIFFERENT HEIGHTS MAKE UP
THE ATTIC OF LA PEDRERA.
THE CATENARY ARCHES,
WITH THEIR PERFECT LOAD
DISTRIBUTION, DO NOT HAVE
TENSION POINTS AND
CONSTITUTE AN ECONOMIC
AND SIMPLE CONSTRUCTION
METHOD. THE BRICKS WORK BY
COMPRESSION, TRANSFORMING
THE ARCH INTO A SINGLE
RESISTANCE STRUCTURE

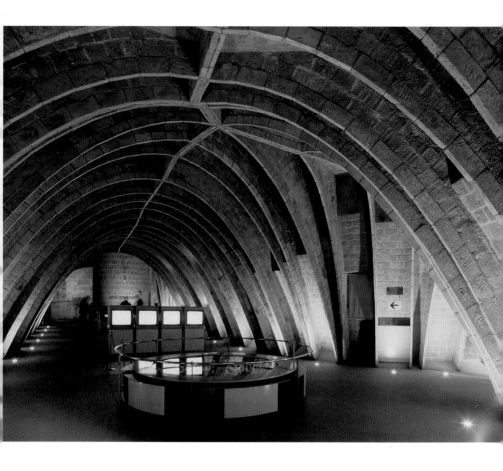

THE ATTIC HAS BEEN ADAPTED BY
THE FUNDACIÓ CAIXA CATALUNYA
TO PROVIDE INFORMATION ABOUT
GAUDÍ, KNOWN AS THE ESPAI GAUDÍ

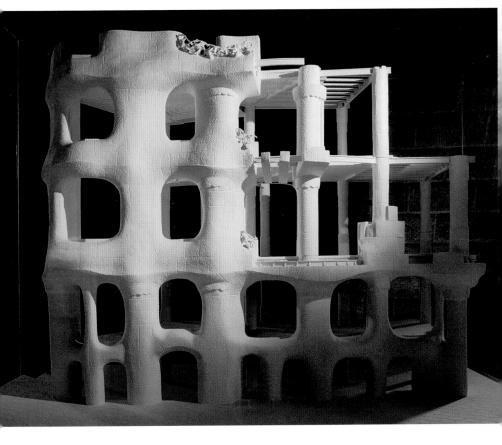

EL SHOWING THE STRUCTURE
A PEDRERA

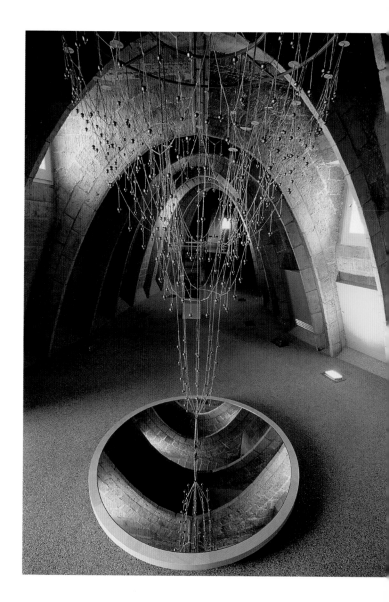

SIMPLIFIED RECREATION OF
THE POLYFUNICULAR MODEL
THAT THE ARCHITECT USED
IN THE CONSTRUCTION OF
THE CHURCH OF THE GÜELL
INDUSTRIAL VILLAGE
→
MODELS OF BUILDINGS
DESIGNED BY THE ARCHITECT
ARE ON SHOW IN THE ESPAI
GAUDÍ

120-121
→
LARGE WINDOWS OF THE
FLATS FACING THE INNER
COURTYARD

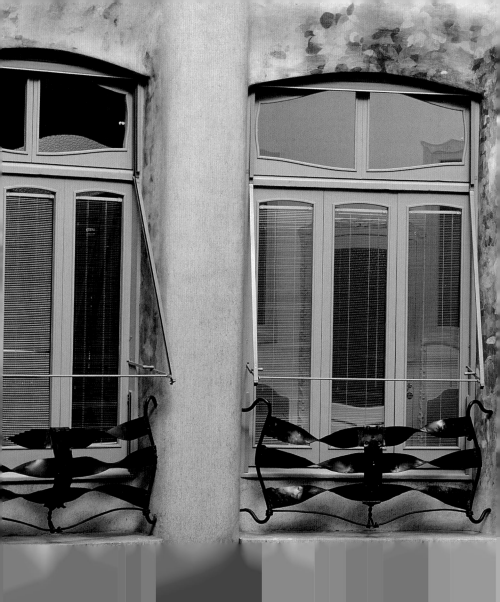

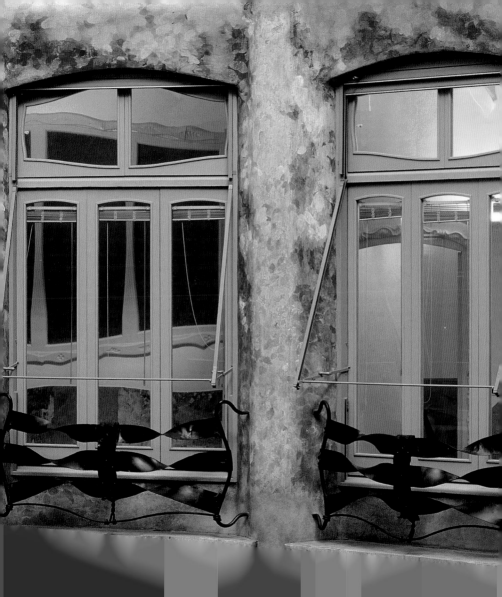

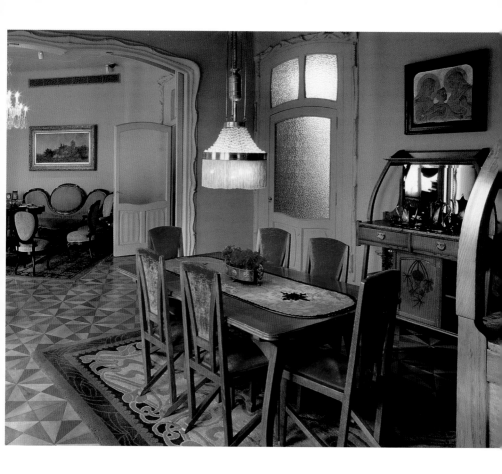

ANOTHER AREA THAT CAN BE VISITED IN
THE CASA MILÀ IS THE RECREATION OF A
FLAT OF THE TIME

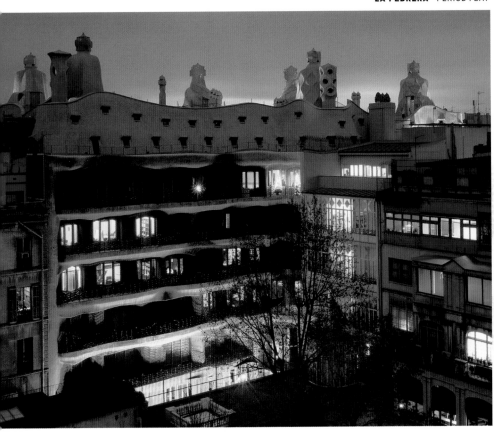

OF THE REAR FACADE FROM THE
OR OF THE BLOCK

P. 126-127
→→
IN A SIMPLIFIED BUT EQUALLY EXPRESSIVE
WAY, ON THE REAR FACADE OF THE CASA
MILÀ THE UNDULATIONS OF THE MAIN
FACADE ARE REPEATED

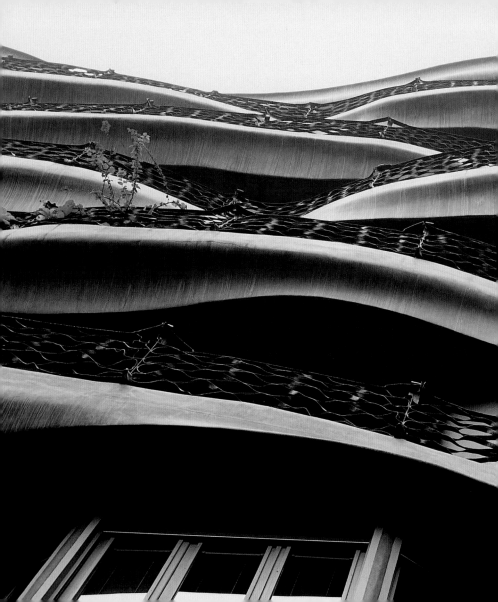

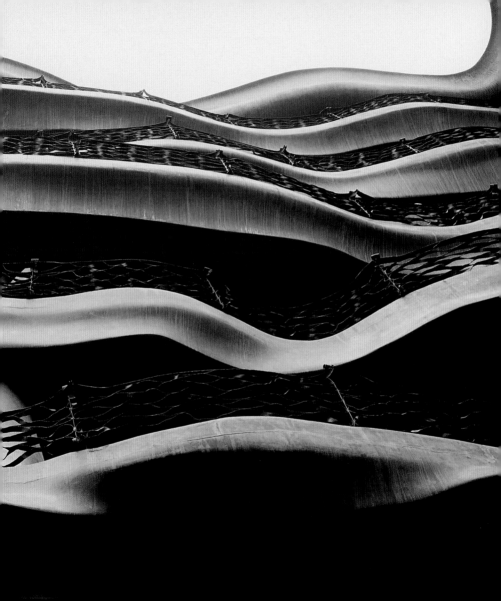

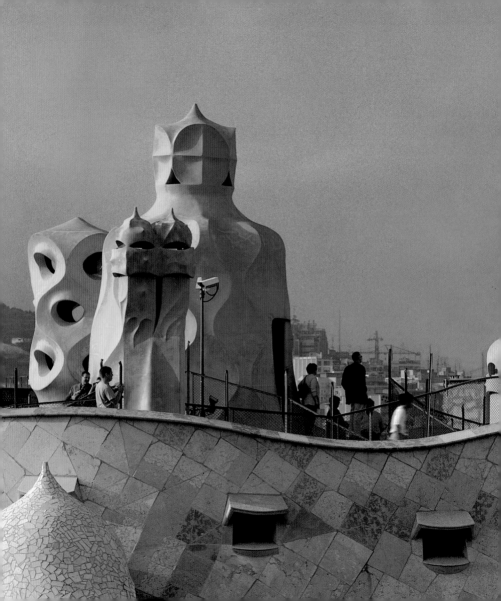

The giants of the terrace

The different heights of the arches in the attic provide the terrace with its sinuous shape. Both spaces are connected by six stairways with a different number of steps. Their stairwells are pavilions that coincide with the highest points of the terrace and appear like giants, like those that are brought out in popular festivals. As in the festivals, they go in pairs, like the king and queen and their long robes. They are abstractions of human figures carrying symbols, such as the crosses of petals and the circles with crosses. All of them are sinuous, above all the tallest ones, with forms that play with the positive and negative. The parapets surrounding the terrace and the walkway are also sinuous and run parallel and facing each other in interplay of concavity and convexity.

←
FLAT ROOF OF THE CASA MILÀ

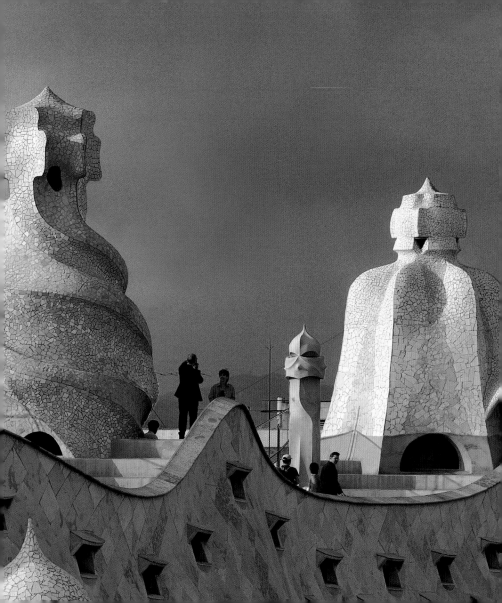

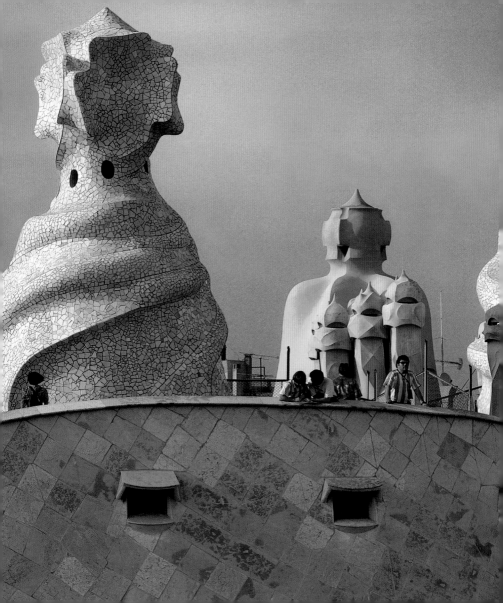

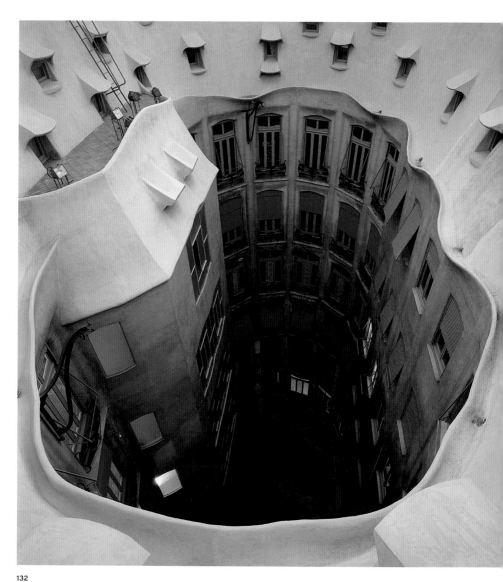

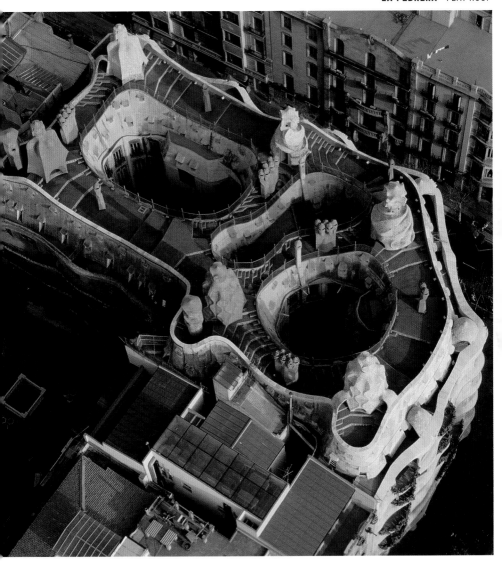

P. 132-133
←←
OVERHEAD VIEW OF THE
COURTYARD AND AERIAL
PHOTO OF THE FLAT ROOF
OF LA PEDRERA

↑
THE ATTIC WINDOWS OPEN
TO COURTYARD INTERIORS
CONTRIBUTED TO
MAINTAINING THE THERMO-
REGULATORY EFFECT, BY
ALLOWING THE INTERIOR TO
BE VENTILATED IN SUMMER
AND CONSERVING THE HEAT
IN WINTER

→
THE FLAT ROOF APPEARS TO
SOFTEN AND MELT OVER THE
VERTIGINOUS GAP OF THE
INNER COURTYARD

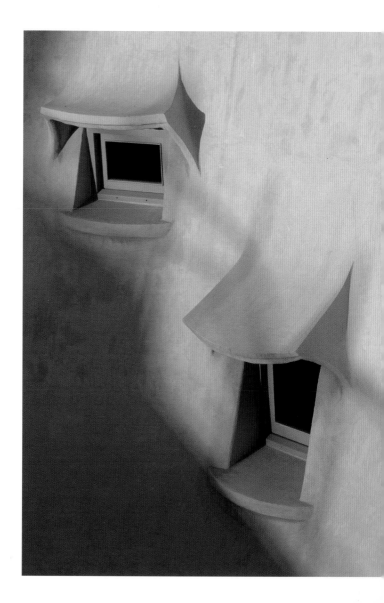

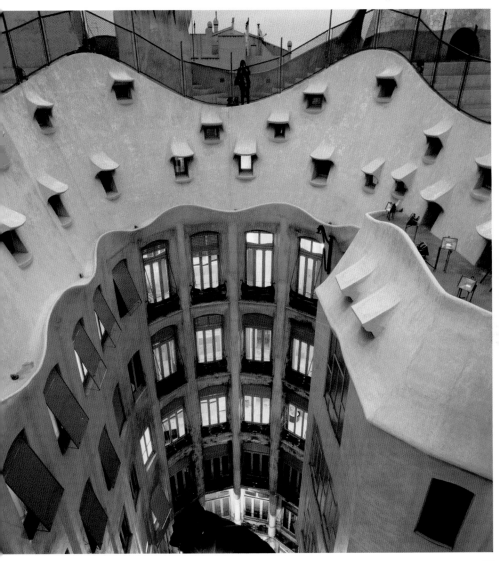

→
AT THE HEIGHT OF THE FLAT
ROOF IS AN UNDULATING
WALKWAY THAT GOES ROUND
THE PERIMETER OF THE
FACADE

P. 138-139
→
THERE ARE THREE TYPES OF
ARCHITECTURAL-SCULPTURAL
ELEMENTS ON THE FLAT ROOF
OF THE CASA MILÀ: SIX
STAIRWAY EXITS, SEVEN
GROUPS OF CHIMNEYS AND
TWO VENTILATION DUCTS
ALL OF THEM, WITH FORMS
ORIGINATING IN REGULATED
GEOMETRY, MAKE UP A
STARTLING GARDEN OF
SCULPTURES

P. 140-141
→→
THE SMALL BUILDINGS FACING
THE STREET ARE COVERED WITH
WHITE MARBLE TRENCADÍS
MOSAIC, WHEREAS THOSE
FACING THE REAR FACADE ARE
RENDERED WITH LIME MORTAR
IN OCHRE TONES

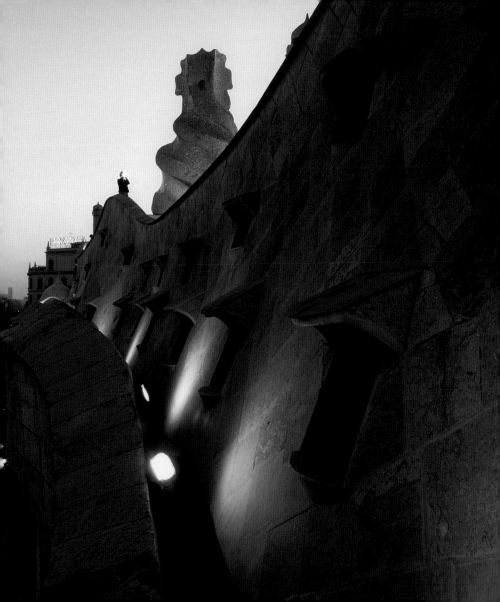

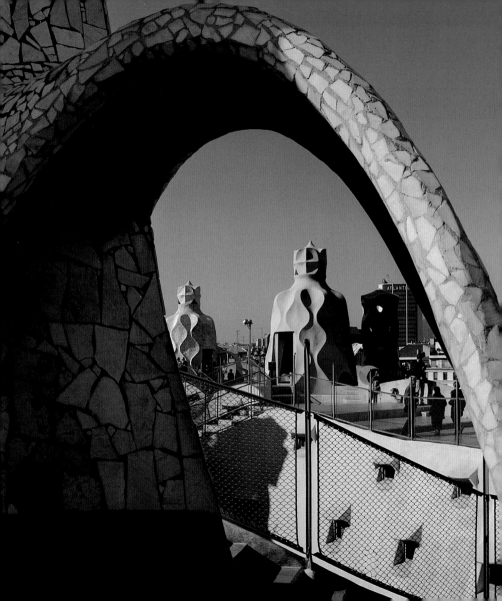

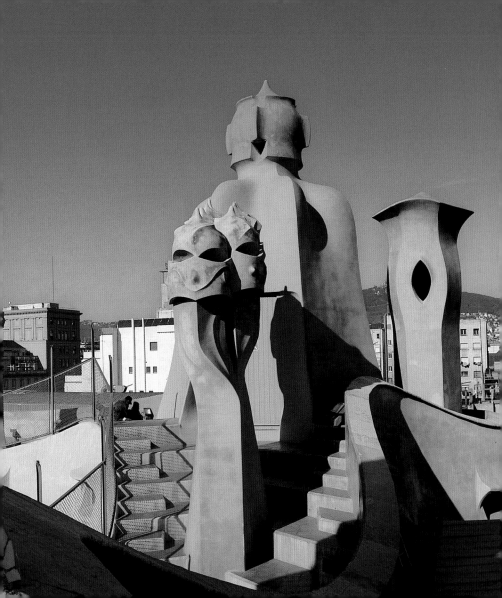

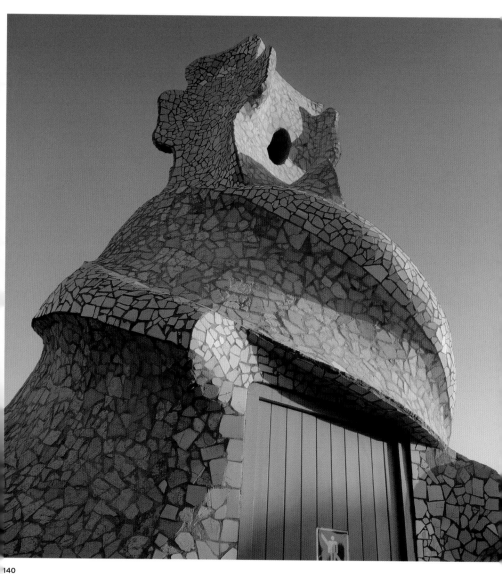

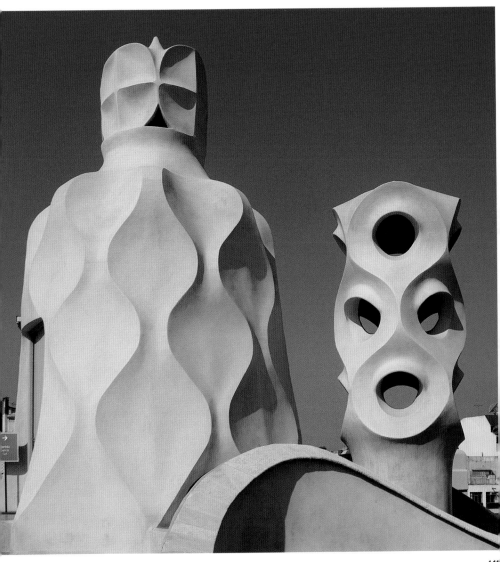

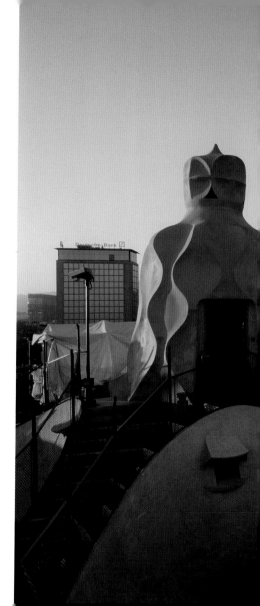

THE SUN'S RAYS CARESS
THE SINUOUS PROFILES OF THE
FIGURES, CREATING A CONSTANT
PLAY OF LIGHT AND SHADE
THAT ENHANCE THE SENSATION
OF MOVEMENT AND
TRANSFORMATION ON THE
FLAT ROOF.
GAUDÍ CONCEIVED THE FLAT
ROOF OF LA PEDRERA AS AN
AUTO SACRAMENTAL (SHORT
THEATRICAL WORKS FROM THE
17TH CENTURY DEDICATED TO
THE EUCHARIST AND FEATURING
ALLEGORICAL CHARACTERS
SUCH AS GOOD, MADNESS...)

144-149
→
THE STAIRWAY EXITS ARE
CROWNED BY FOUR-SIDED
CROSSES FACING THE CARDINAL
POINTS

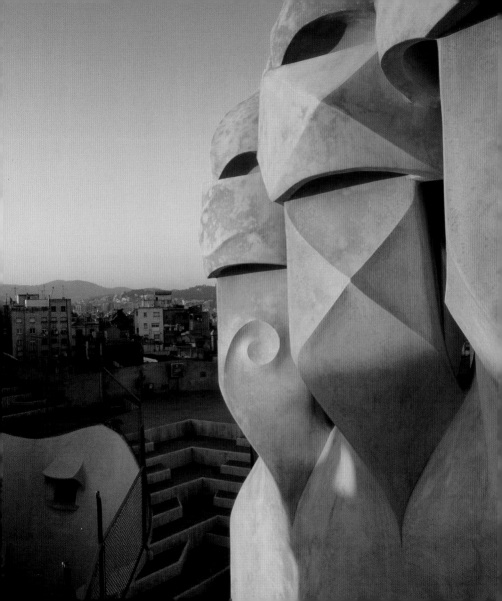

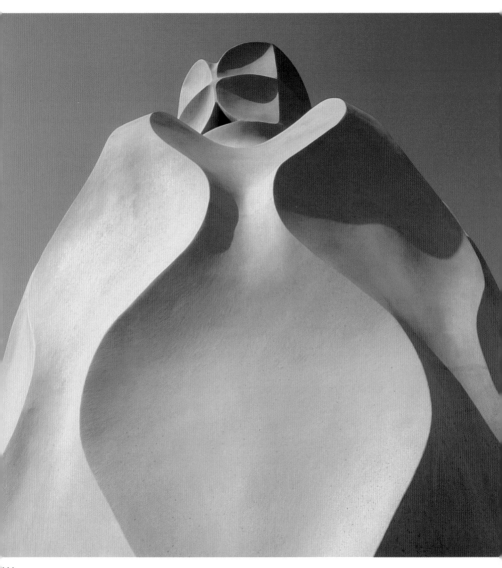

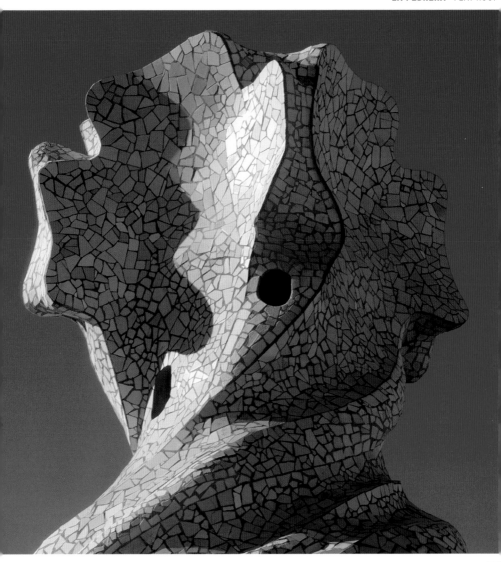

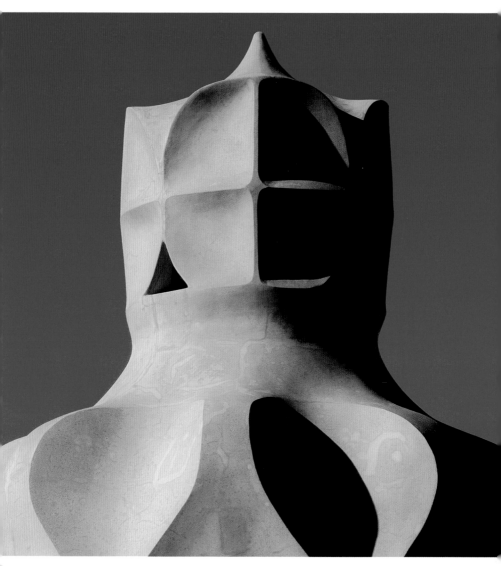

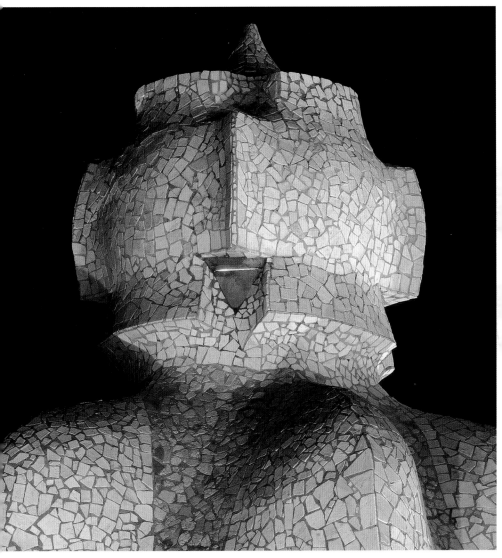

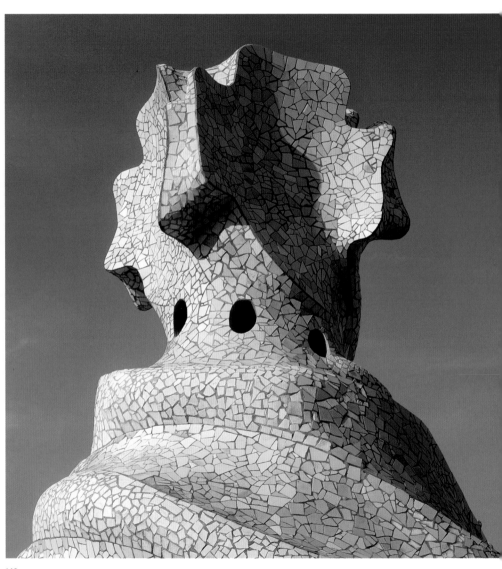

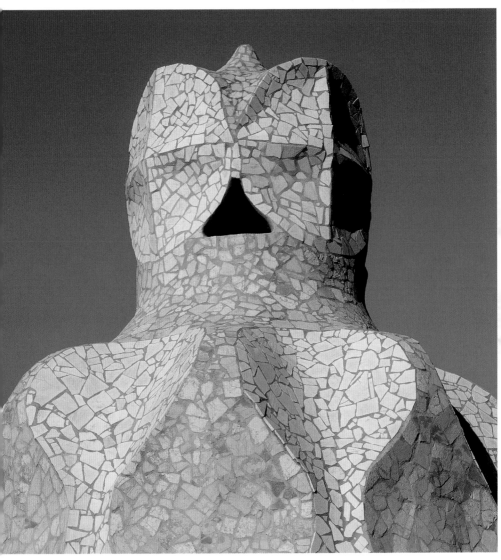

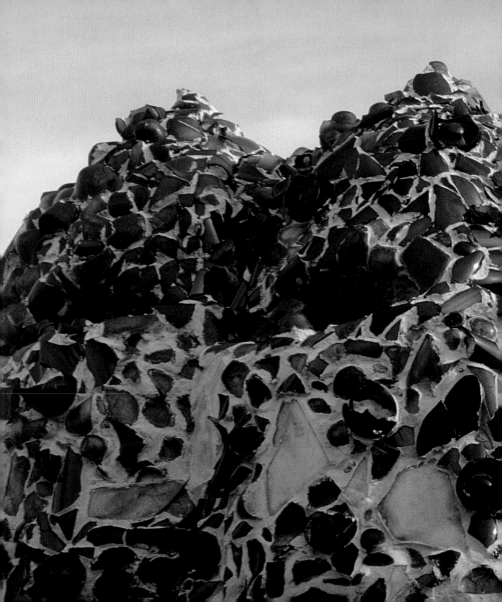

La Pedrera is the cosmos

As Gaudí himself suggested, the terrace of the Casa Milà is a complex and changing 17th century religious play of allegorical figures watched over by an army of chimneys. These represent the characters of the grand theatre of the world. They are symbols of the family, parents, sons, daughters, lovers and warriors... In La Pedrera what is below is similar to that which is above, stone is water and truth is falsehood. La Pedrera is the cosmos.

←
CHIMNEYS COVERED WITH
PIECES OF GLASS BOTTLES

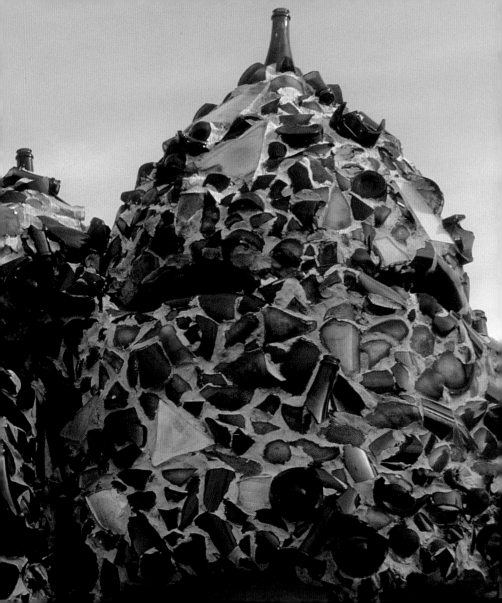

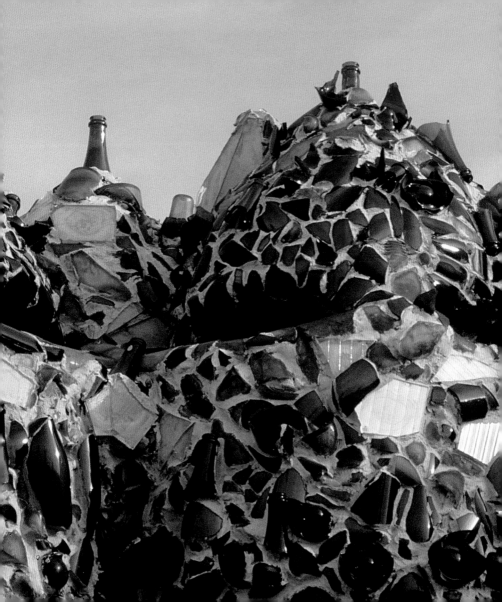

→
THE CHIMNEYS, THE ETERNAL
AND IMMOBILE GUARDIANS, ARE
THE MOST POPULAR ELEMENTS
OF LA PEDRERA

→
GAUDÍ'S EXPERIMENTATION
WITH NEW MATERIALS AND
TEXTURES IS CONTINUOUS. IN
THIS CASE THE FRAGMENTS OF
BOTTLES ARE TRANSFORMED
INTO A UNIQUE CHIMNEY
COVERING

P. 156-157
→→
THE SCULPTURES ON THE FLAT
ROOF SEEM TO HAVE BEEN
MOULDED BY THE EROSIVE
EFFECT OF WATER AND WIND
THROUGH TIME. THIS
GEOLOGICAL APPEARANCE
REMINDS ONE OF THE MAGICAL
UNIVERSE OF MEGALITHIC
CONSTRUCTIONS

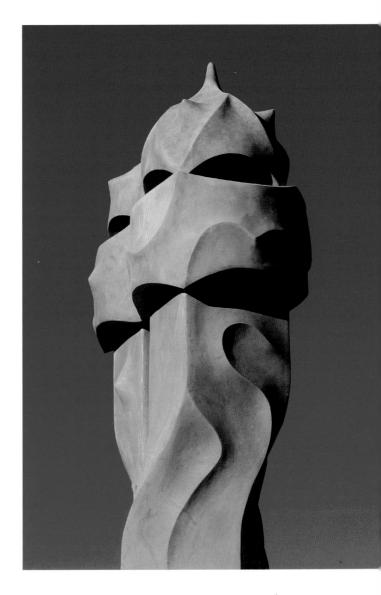

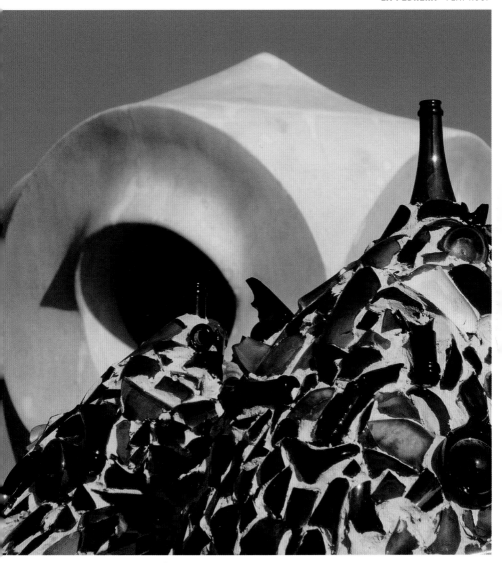

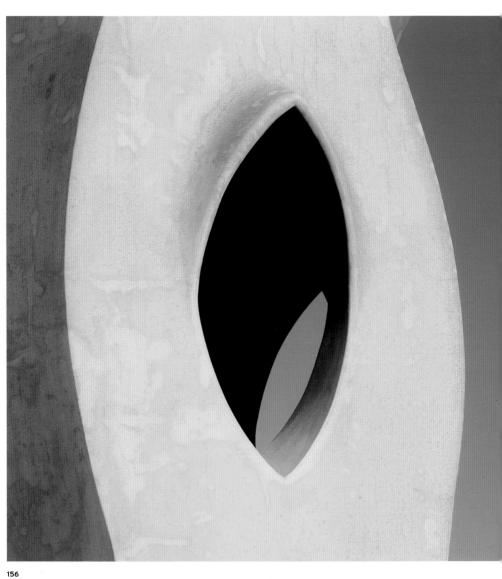

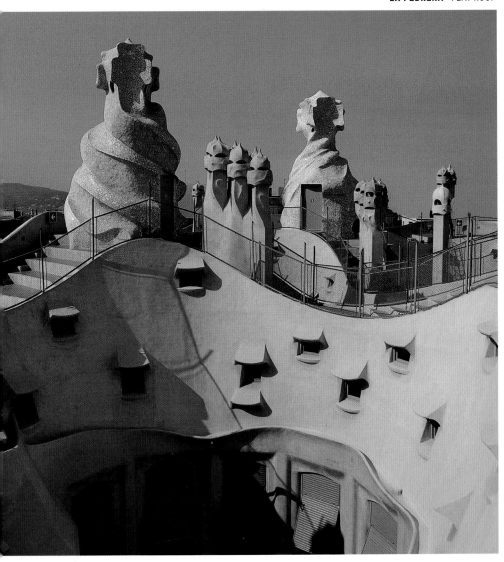

THE BODIES OF THE WARRIORS-
CHIMNEYS ARE MARKED BY
ENIGMATIC SIGNS THAT
EMPHASISE THEIR DISTURBING
APPEARANCE

P. 160-165
→
ELEMENTS OF THE ROOFING CAP

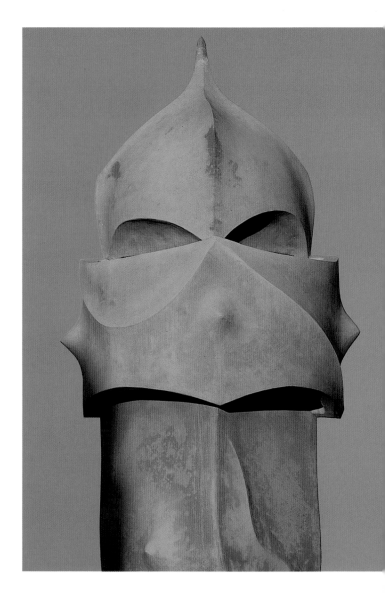

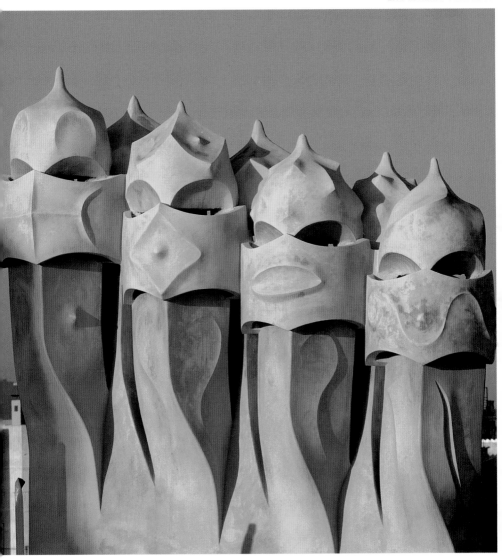

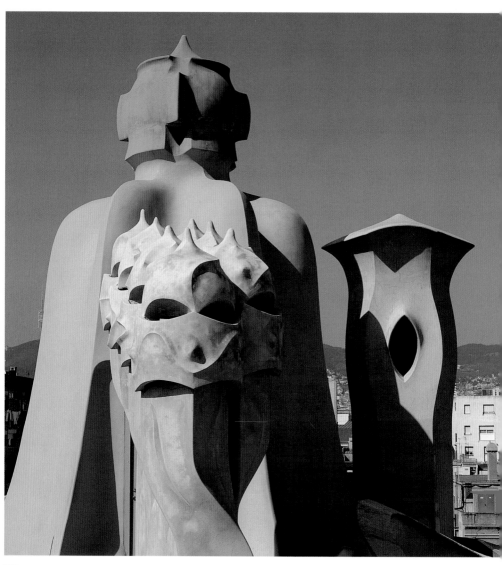

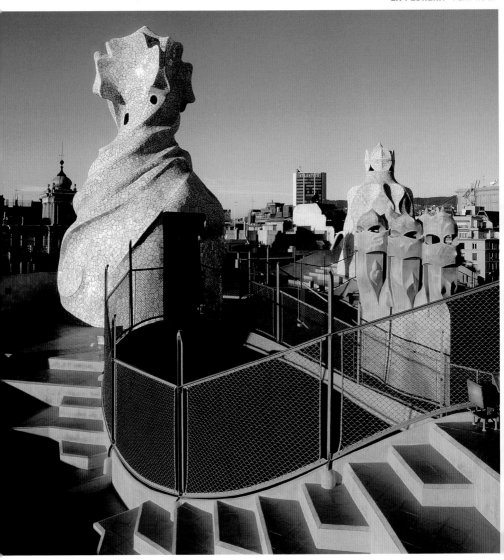

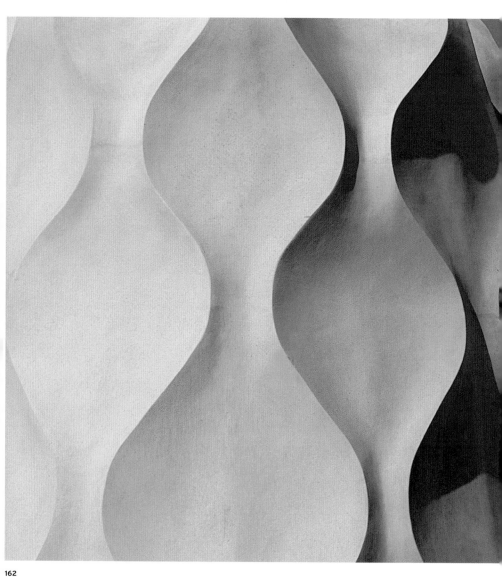

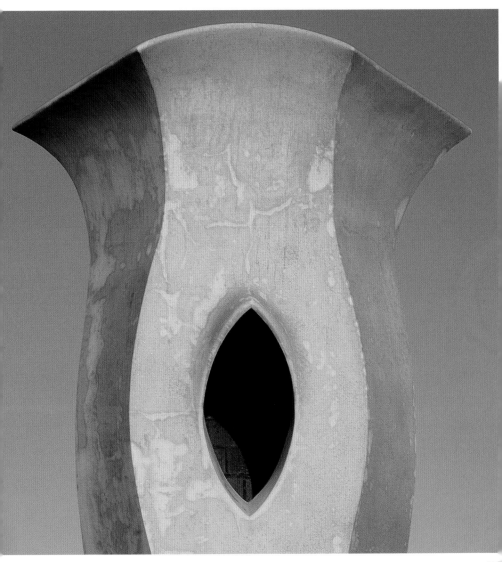

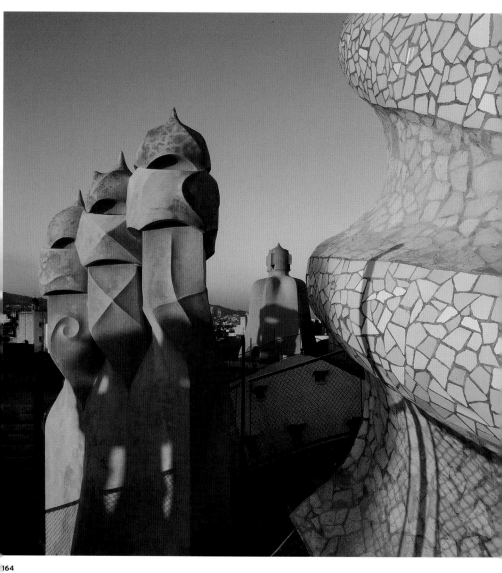

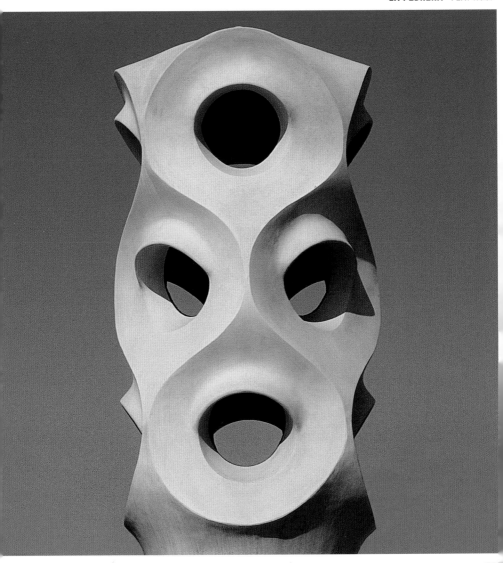

NIGHT-TIME BRINGS WITH IT
THE MORE SUGGESTIVE AND
MYSTERIOUS NATURE OF THE
FLAT ROOF, A LAND OF
SYMBOLS WHERE THE SUBTLE
VEIL SEPARATING REALITY
FROM FANTASY VANISHES

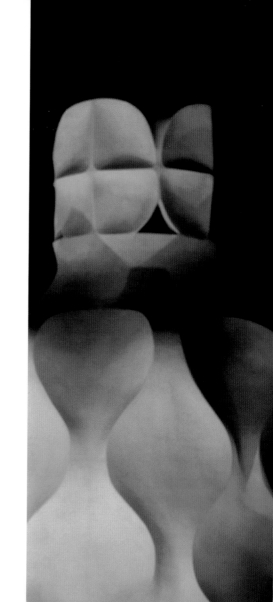

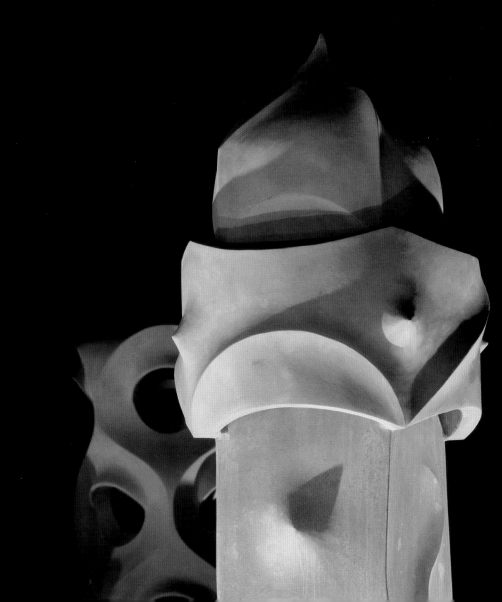

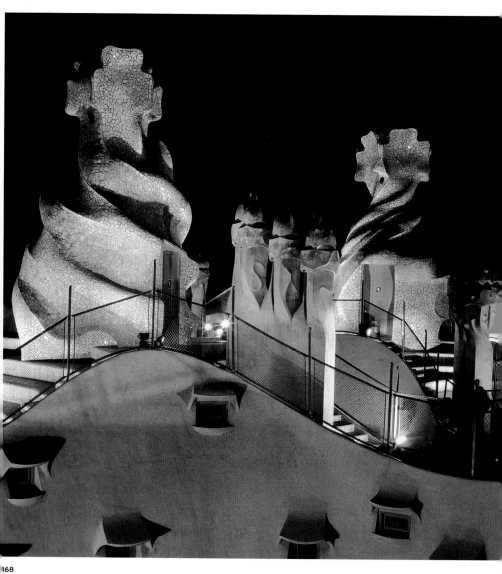

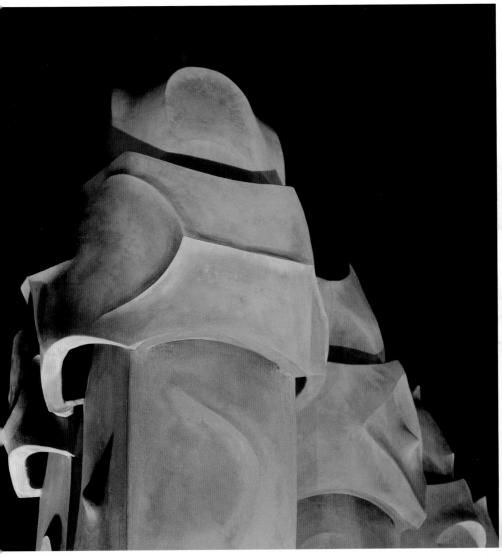

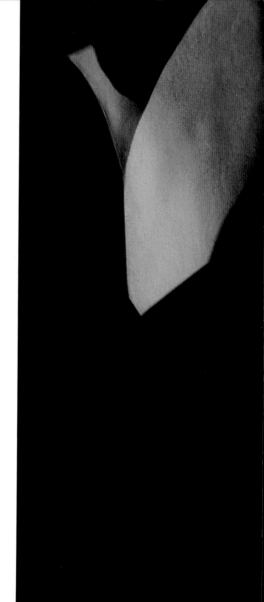

"BEAUTY IS THE SHINING
OF THE TRUTH. AS ART
IS BEAUTY, WITHOUT TRUTH
THERE IS NO ART"
Antoni Gaudí

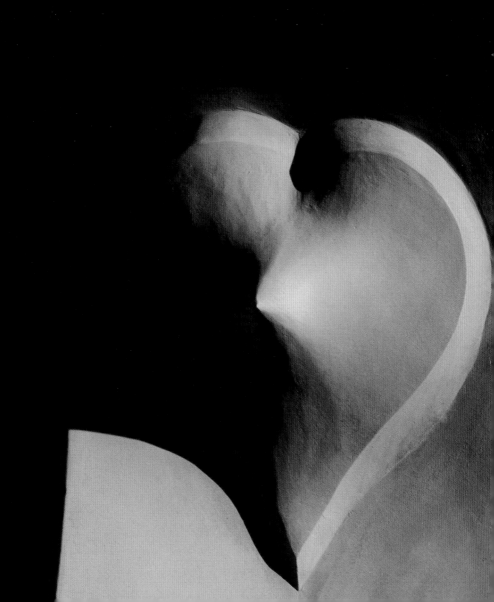

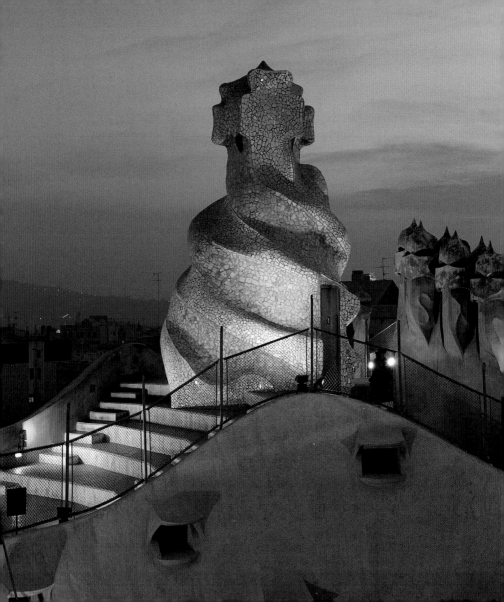

A startling building

n his work *Homenots*, Josep Pla wrote, "When I arrived in Barcelona in the second decade of the century, Gaudí was very famous but his work advanced amidst a great deal of controversy". In 1929, Christian Zervos published in *Cahiers d'Art*, "Gaudí is the architect who has discredited the city of Barcelona with his many constructions, dishonouring all those who have trusted in his housing". In 1933 Dalí wrote an article defending the figure of Gaudí for the magazine *Minotaure*. Today, architects such as Foster and Isozaki consider this building as an unmistakable milestone if we want to understand the history of architecture.

Throughout its existence, La Pedrera has not lost any of its ability to cause controversy, admiration and even rejection. The construction of this colossus was seen as a show, as can be seen from the publications of the time. Emerging from the deep recesses of Gaudí's imagination, this sea of stone was, is and will be a startling experience for whoever steps inside its swell of shapes and sensations.

GHT VIEW OF THE FLAT ROOF
LA PEDRERA

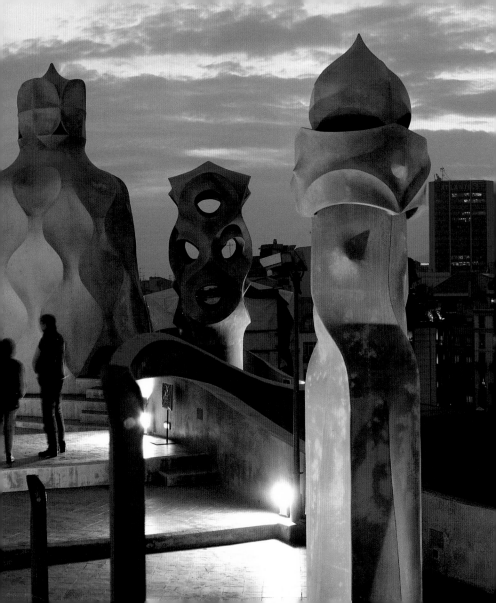

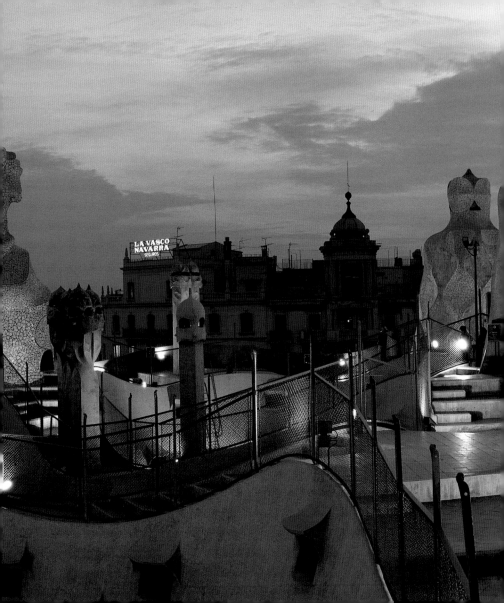

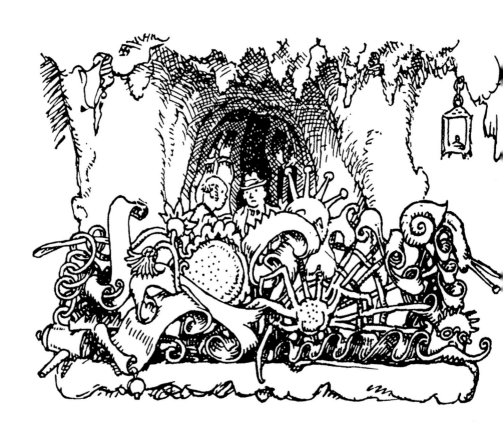

ILLUSTRATION BY JUNCEDA OF
THE BALCONIES OF LA PEDRERA
PUBLISHED IN THE MAGAZINE
"EN PATUFET", 1925

→
GAUDÍ BEFORE LA PEDRERA IN A
SKETCH THAT COPIES THE POSTER
ADVERTISING "THE TWILIGHT OF
THE GODS " OPERA BY WAGNER

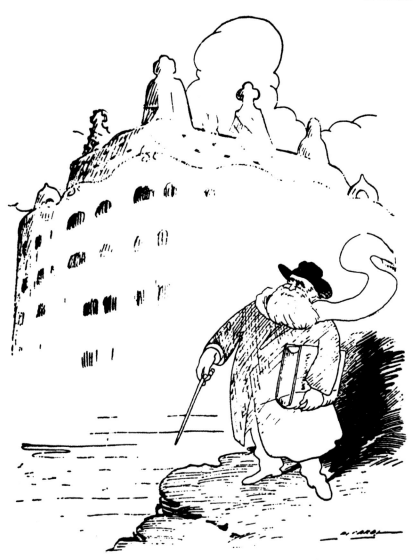

THE COMIC STRIPS OF THE
PUBLICATIONS OF THE TIME
SHOW THAT THE CASA MILÀ
WAS A BUILDING THAT
PROVOKED ALL TYPES OF
REACTION. IT WAS COMPARED
WITH A CREEPY GROTTO
WHERE VERMIN STORE THE
REMAINS OF THEIR BANQUETS,
OR A GIANT STALL FOR
SELLING COD

→
GAUDÍ WANTED TO PLACE
A SCULPTURE OF THE VIRGIN
AT THE TOP OF LA PEDRERA.
PEDRO MILÁ WAS AGAINST
THE IDEA AND FOR THIS
REASON, AS WELL AS FOR
ECONOMIC QUESTIONS, A
CONFLICT AROSE THAT WOULD
END WITH GAUDÍ BRINGING AN
ACTION AGAINST THE MILÀ
FAMILY. THE SATIRICAL
MAGAZINES ALSO PUBLICISED
THIS EPISODE

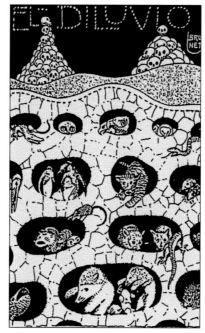

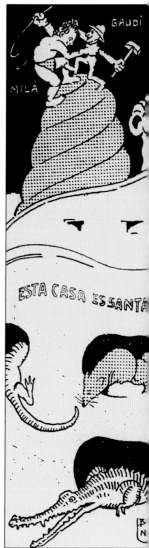

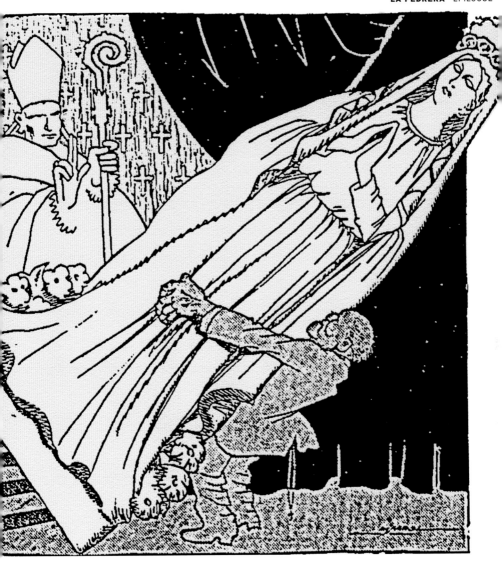

DRAWING BY JOAN MATAMALA
OF THE SCULPTURAL SERIES
BY CARLES MANI DEDICATED
TO THE VIRGIN WHICH SHOULD
HAVE CROWNED THE BUILDING

182-183
→
FOR THE MILÀ FAMILY,
ACCORDING TO THEIR OWN
WORDS, "THE HOUSE THAT
GAUDÍ HAD BUILT FOR THEM
WAS SIMPLY HORRIBLE"
THE DISAGREEMENTS WITH
GAUDÍ MADE IT IMPOSSIBLE TO
CREATE A SPECIFIC PROPERTY
AND THE DECORATION OF THE
MAIN FLOOR FOLLOWED NEO-
CLASSICAL GUIDELINES IN LINE
WITH THE TASTE OF THE TIME

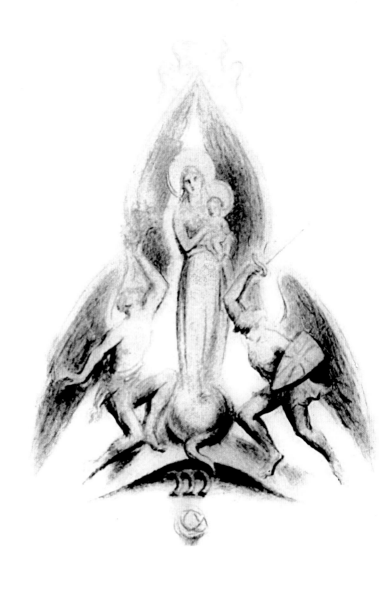

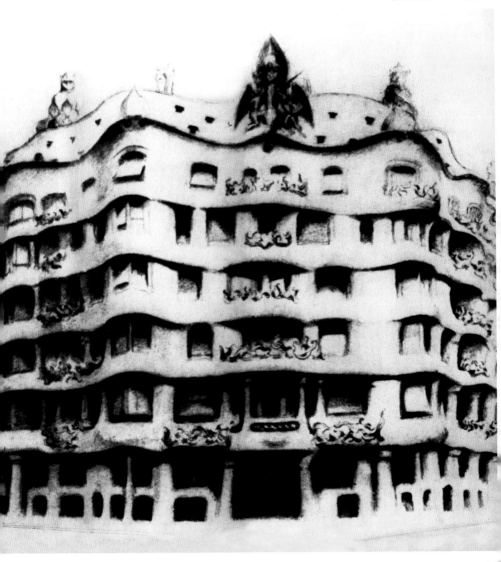

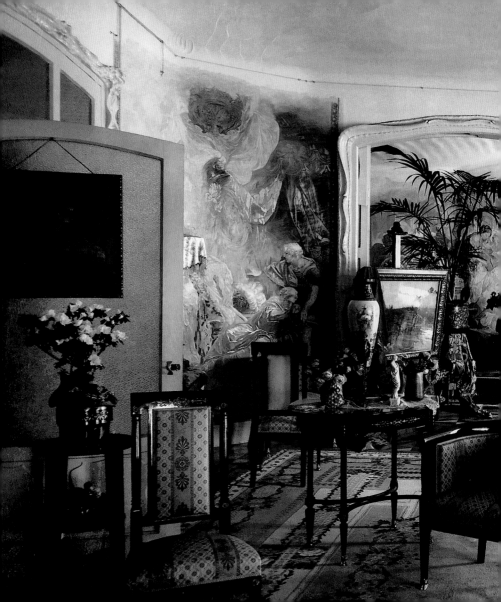

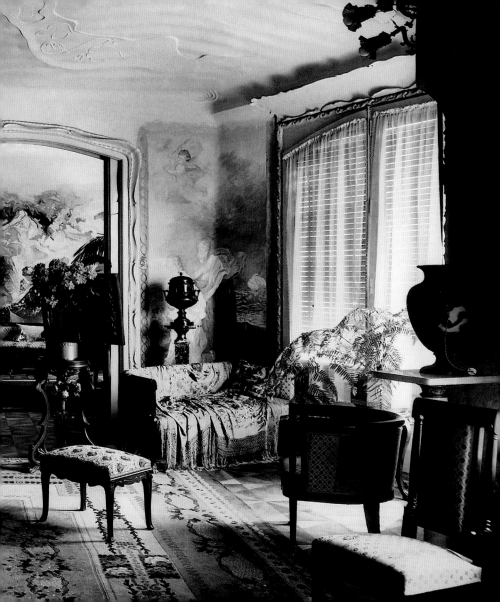

↑
PHOTOGRAPHS OF LA
PEDRERA IN CONSTRUCTION

→
ONCE THE STONES ON THE
FACADE WERE PLACED, THE
EDGES WERE ADJUSTED AND
OUTLINE RETOUCHED
ACCORDING TO GAUDÍ'S
INSTRUCTIONS.
THE PHOTOGRAPH SHOWS
THE FACADE STONES BEFORE
BEING ROUGH-HEWN

186-187
→
GAUDÍ'S ORIGINAL PLANS
DIFFERED GREATLY FROM THE
FINAL RESULT. THE INITIAL
PROJECT FOR THE FACADE
SHOWS CERTAIN SIMILARITIES
WITH THE CASA BATLLÓ

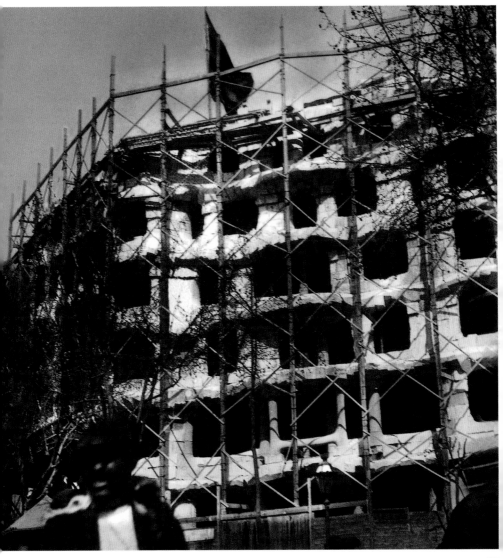

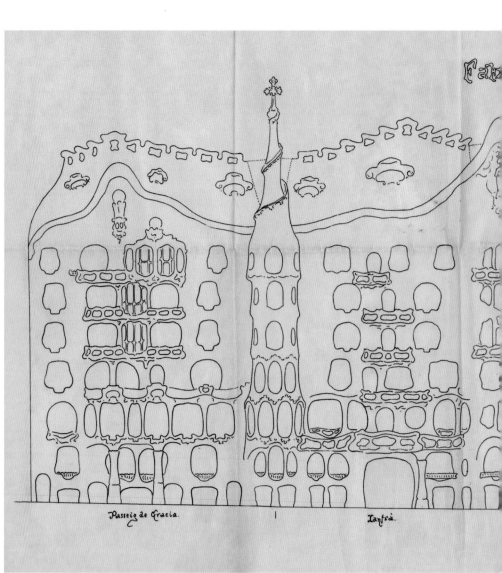

Passeig de Gracia. | Xanfrà.

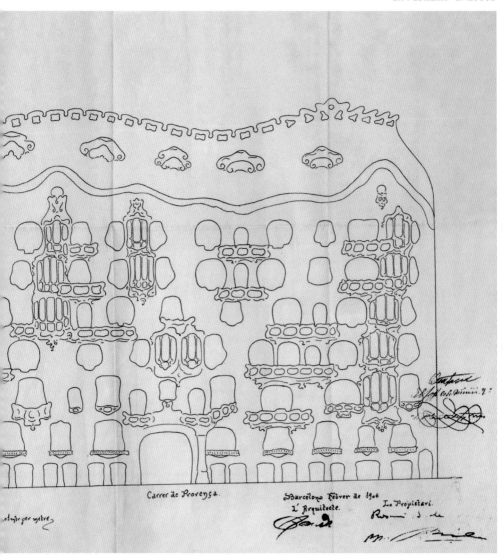

Carrer de Provença.

Barcelona febrer de 1906

L'Arquitecte.

Lo Propietari.

metre per metre

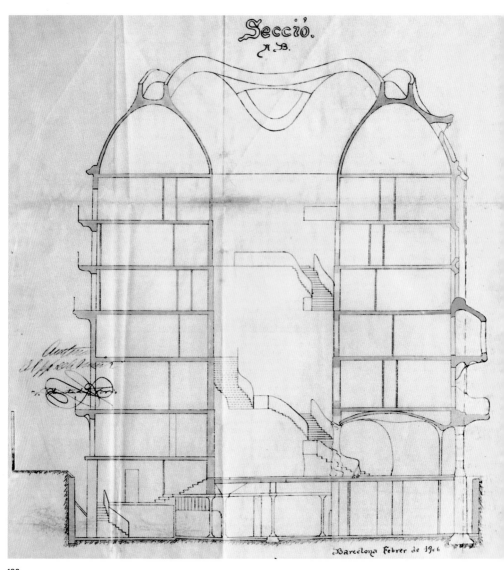

Secció.
A. B.

Barcelona Febrer de 1906

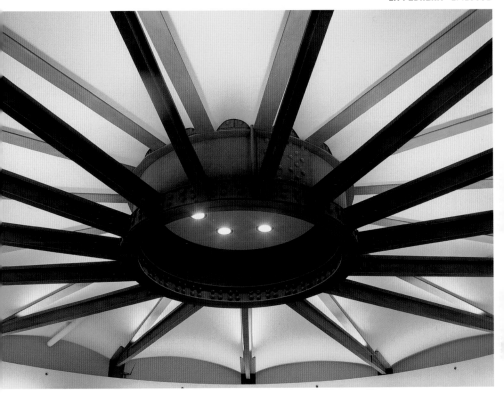

N OF LA PEDRERA
DING TO THE ORIGINAL
CT SIGNED BY GAUDÍ AND
NTED TO THE COUNCIL IN

GAUDÍ WAS AHEAD OF HIS TIME
IN PROJECTING A METALLIC
STRUCTURE IN THE FORM OF
A BICYCLE WHEEL AS A SUPPORT
FOR THE CIRCULAR COURTYARD
IN PASSEIG DE GRÀCIA

CASA MILÀ "LA PEDRERA"

PROMOTER:
PEDRO MILÀ I CAMPS

PROJECT:
2ND OF FEBRUARY 1906

CONSTRUCTION:
1906 - 1912

MAIN COLLABORATORS:
JOSEP MARÍA JUJOL
FRANCESC DE PAULA QUINTANA
JOSEP CANALETA
JAUME BAYÓ
JOAN RUBIÓ
DOMÈNEC SUGRAÑES
(ARCHITECTS)

ALEIX CLAPÉS
IU PASCUAL
XAVIER NOGUÉS
LLUÍS MORELL
(PAINTERS)

JOAN MATAMALA
JAUME BERTRÀN
(MODELLERS)

FRATELLI BADIA
(WROUGHT IRON WORKERS)

CONSTRUCTOR:
JOSEP BAYÓ FONT

1947, ROSER SEGIMON SELLS
THE CASA MILÀ
1962, BARCELONA ARTISTIC
HERITAGE SITE
1969, NATIONAL HERITAGE SITE
1985, UNESCO WORLD HERITAGE
SITE
1986, ACQUISITION AND
RESTORATION OF THE BUILDING
BY CAIXA CATALUNYA

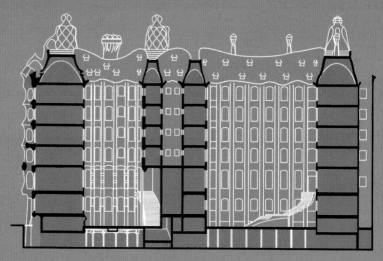

SECTION

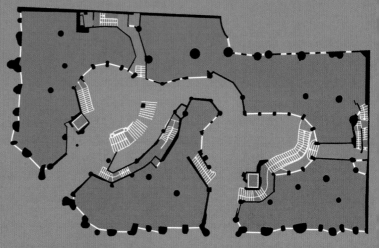

GROUND FLOOR

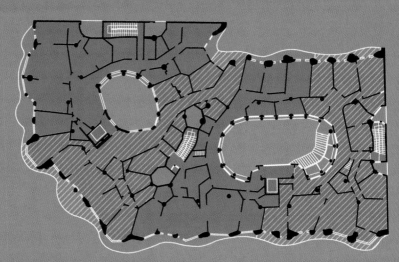

FIRST FLOOR

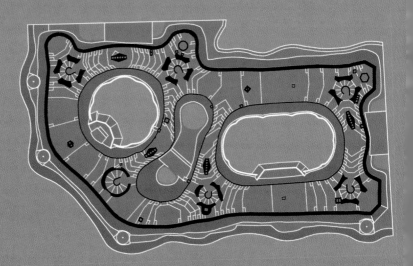

FLAT ROOF

© 2002, TRIANGLE POSTALS

© TEXT
Josep Mª Carandell

© PHOTOGRAPHY
Pere Vivas

© ARCHIVE PHOTOGRAPHS
Reial Càtedra Gaudí, p. 109, 180, 181, 184, 185
Arxiu Mas, p. 182

COMPLEMENTARY TEXTS
Triangle Postals

PLANS
Fernando Marzá

ACKNOWLEDGEMENTS
Fundació Caixa Catalunya
Theatre Company Royal de Luxe

DESIGN
Joan Colomer

TRANSLATION
Steve Cedar

COLOUR SEPARATIONS
Tecnoart

PRINTED BY
Grup 3 S.L. Barcelona

DIPÓSITO LEGAL
B-44.032 - 2002

ISBN
84-8478-020-1

Triangle Postals S.L.
+34 971 15 04 51, +34 93 218 77 37
+34 971 15 18 36
e-mail: paz@teleline.es
www. trianglepostals.com

gaudí 2002
Any Internacional Gaudí
Año Internacional Gaudí
Gaudí International Year